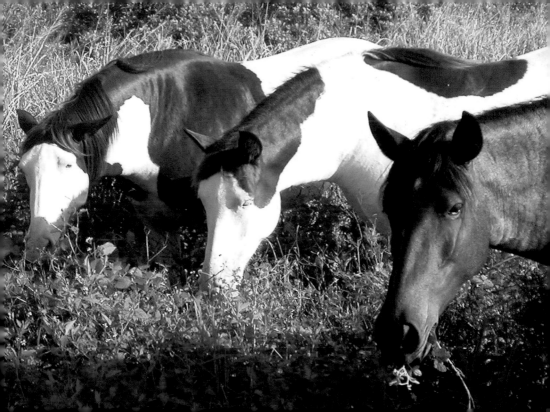

Akhal-Teke

The color of the Akhal-Teke ranges from palomino to light bay and roan, always with a golden metallic gleam to the coat. It was among the world's first hot-blooded breeds, developed by nomadic tribes in Asia.

HEIGHT: 15–16 hands

DESCRIPTION: Lean build with a long, thin neck; sloping croup, long pasterns, pronounced withers, sparse mane and tail, and lustrous coat. Many colors including bays, chestnuts, dun, palomino, grullo, cremello, perlino, and black.

SPECIAL QUALITIES: Metallic sheen to coat; soft, gliding gaits; extraordinary endurance

BEST SUITED FOR: Endurance and dressage

PLACE OF ORIGIN

Turkmenian desert east of the Caspian Sea

PONY

LIGHT HORSE

HEAVY HORSE

COLOR

4

PONY

LIGHT HORSE

HEAVY HORSE

COLOR

American Cream Draft

The American Cream Draft is one of only a few draft breeds that were developed entirely in the United States. Many of these horses are used for pleasure driving and riding, and at least one shows in dressage.

HEIGHT: Mature mares, 15–16 hands; mature males, 16–16.3 hands

DESCRIPTION: Refined head with large eyes, small ears, and flat profile; long, full mane and tail; wide chest, deep heart girth, and solid, strong legs set wide apart. Always cream-colored — light, medium, or dark; pink skin; white mane and tail; amber or hazel eyes.

SPECIAL QUALITIES: Unusual striking cream color

BEST SUITED FOR: Commercial carriage driving, parade hitches, farm work, riding, and pleasure driving

PLACE OF ORIGIN

Iowa

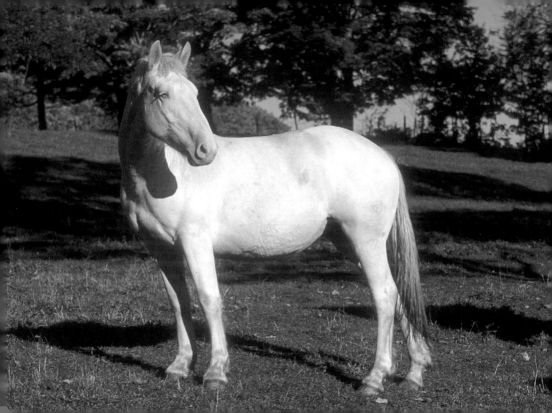

American Curly Horse

When viewed in the right light, the Curly coat has a wavy pattern similar to that of rippling water. Not only do Curlies have a curly mane, tail, and coat, but many even have curls in their ears.

HEIGHT: 14.3–15.2 hands

DESCRIPTION: A sturdy horse with wide-set eyes, a muscular neck, extremely hard, round hooves. All common colors.

SPECIAL QUALITIES: Unique curly coat and mane; smooth lateral gaits; unusually hardy

BEST SUITED FOR: Ranch work, trail riding, endurance, and all pleasure sports

PLACE OF ORIGIN

Unknown; first recorded in Nevada

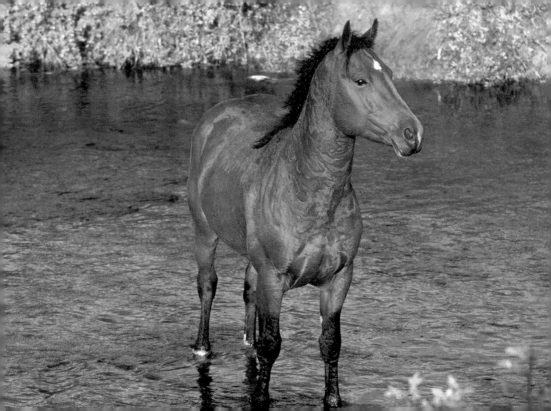

American Indian Horse

These horses transformed entire indigenous cultures into swift nomadic hunters and fearsome mounted warriors. Used as warhorses, racehorses, stock horses, and beasts of burden, they truly changed the face of a nation.

HEIGHT: 13–16 hands

DESCRIPTION: The American Indian Horse is the name now given to all Indian horses. Typically small and tough, with great endurance, individual populations vary according to tribal preferences. All colors known to the horse.

SPECIAL QUALITIES: Tough and durable; features vary according to tribal and family lines

BEST SUITED FOR: Endurance

PLACE OF ORIGIN

Throughout North America

PONY

LIGHT HORSE

HEAVY HORSE

COLOR

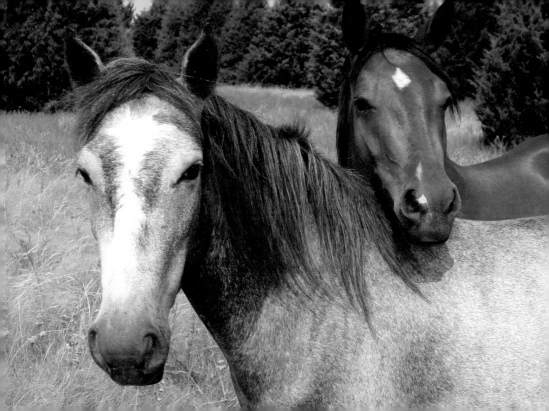

American Paint Horse

Colored horses came to the Americas with Cortés and have been extremely popular ever since. American Paint Horses are now found throughout the world. They excel in all working and pleasure disciplines.

HEIGHT: 14.2–16.2 hands

DESCRIPTION: Solid stockhorse conformation; striking color patterns. Major patterns are tobiano (regular spots, white extending across back; often four white stockings and blaze or star on face, multicolored tail) and overo (irregular, splashy white markings not extending across back; at least one leg colored; often a bald or bonnet face; tail of one color).

SPECIAL QUALITIES: Versatility, athleticism, gentle temperament

BEST SUITED FOR: Western competition, ranch work, trail riding, and all working and pleasure disciplines

PLACE OF ORIGIN

The American West

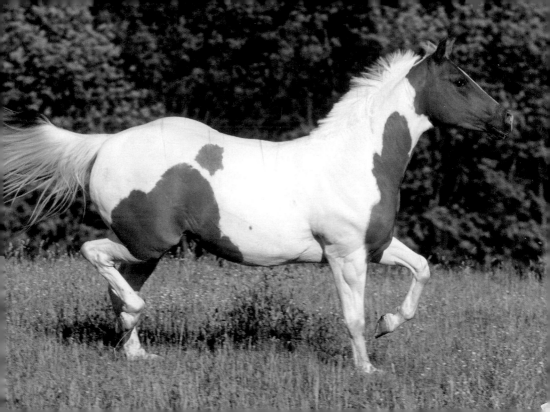

PONY

LIGHT
HORSE

HEAVY
HORSE

COLOR

American Quarter Horse

Originally developed on the East Coast to run races over short distances, the Quarter Horse found its place in the development of the West as an outstanding ranch horse with innate "cow sense."

HEIGHT: 14.2–17 hands

DESCRIPTION: Short, fine head with straight profile; small, alert ears and lively eyes set well apart; solid, muscular body. Many colors appear, but sorrel is the most common.

SPECIAL QUALITIES: Exceptional athleticism and versatility; extreme speed for short distances; most highly developed "cow sense" of any breed

BEST SUITED FOR: Ranch work; short-distance racing, cutting, reining, and other competition

PLACE OF ORIGIN

North America; originated along the eastern seaboard and became a breed on the ranches of the American West

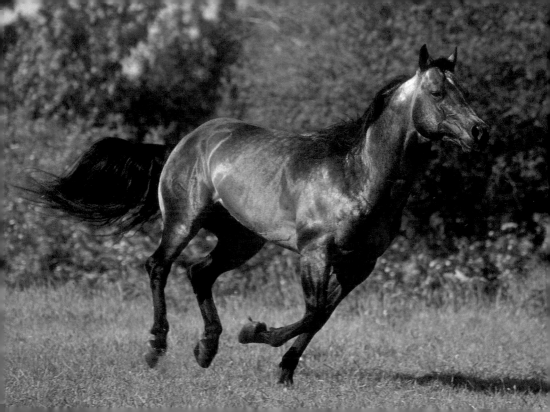

PONY

LIGHT
HORSE

HEAVY
HORSE

COLOR

American Quarter Pony

Known for their calm disposition, quickness, and agility, Quarter Ponies are popular mounts for Western competitions such as bulldogging, roping, and team penning. They make excellent trail and family mounts as well.

HEIGHT: 11.2–14.2 hands

DESCRIPTION: Small, chiseled head with bold eyes often showing white sclera; long, arched neck and moderately high withers; long, sloping shoulders and deep heart girth. All solid colors and pinto.

SPECIAL QUALITIES: Extremely athletic, heavily muscled, stock-type animals

BEST SUITED FOR: Western competition and ranch work

PLACE OF ORIGIN

The first Quarter Pony Association started in Iowa, but the breed has long been found across the United States.

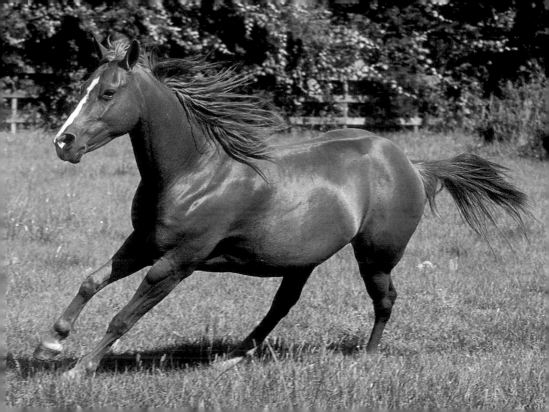

American Saddlebred

These beautiful horses, with their graceful bearing, are spirited yet gentle and easily trainable. They carry themselves elegantly and are a pleasure to ride and to watch at all times.

HEIGHT: 15–17 hands

DESCRIPTION: Finely chiseled heads with small, alert ears and large eyes; long, arched neck; wide-chested with short strong back and powerful hindquarters. All colors.

SPECIAL QUALITIES: Elegance and beauty; can have two extra gaits, the slow gait and the rack

BEST SUITED FOR: Showing (riding and driving); trail and pleasure riding

PLACE OF ORIGIN

Eastern United States, especially Kentucky

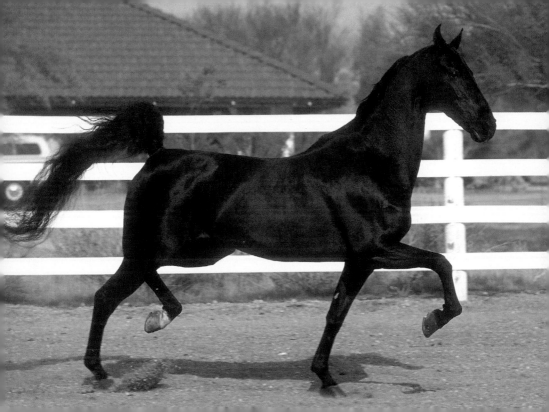

PONY

LIGHT
HORSE

HEAVY
HORSE

COLOR

gaited

20

American Walking Pony

These ponies' natural gaits are the walk, pleasure walk, merry walk, trot, and canter. Some also perform the slow gait and the rack, making them seven-gaited. They combine Welsh Pony and Tennessee Walker bloodlines.

HEIGHT: 13.2–14.2 hands

DESCRIPTION: Small, chiseled head with bold eyes showing white sclera; long, arched neck and moderately high withers; long, sloping shoulders and deep heart girth. All solid colors and pinto.

SPECIAL QUALITIES: A gaited pony breed of great beauty, versatility, and athleticism; some individuals can perform seven gaits

BEST SUITED FOR: Pleasure, driving, jumping, and trail riding

PLACE OF ORIGIN

Georgia

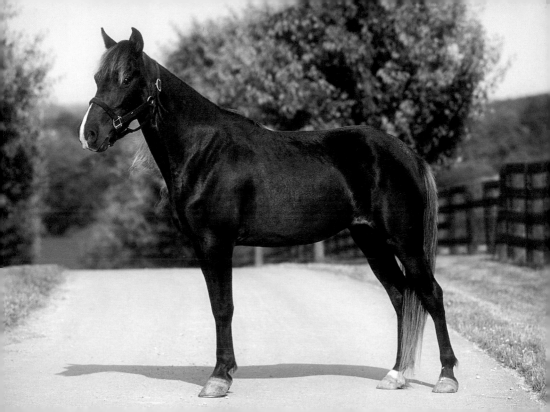

PONY

LIGHT
HORSE

HEAVY
HORSE

COLOR

Andalusian

Not only does the Andalusian have stunning visual appeal, but it also has a gentle, willing disposition. Along with the Lusitano, a close relative, this breed has long been considered one of the finest in the world.

HEIGHT: 15–16 hands

DESCRIPTION: Straight or slightly convex profile on head of great elegance and character; highly arched neck; solid build; rounded croup with low-set tail. Solid colors only, most commonly bay, gray, and black.

SPECIAL QUALITIES: Exceptionally even temperament, elegance, agility, power, "cow sense"

BEST SUITED FOR: Dressage, all general riding purposes, ranch and cattle work, and mounted bullfighting

PLACE OF ORIGIN
Spain; came to New World with Columbus

Appaloosa

During the nineteenth century the Ni Mee Poo (Nez Percé) Indians bred these spectacular horses, which quickly became famous for their speed, surefootedness, and tremendous endurance.

PONY

LIGHT HORSE

HEAVY HORSE

COLOR

HEIGHT: 14.2–16.2 hands

DESCRIPTION: Although the color is the most obvious feature of Appaloosas, their strength and versatility are prized by horsemen. One of the most common Appaloosa patterns is the blanket (shown).

SPECIAL QUALITIES: Bold coat-color patterns; striped hooves; mottled skin on nose, lips, and genitals

BEST SUITED FOR: Ranch work, trail riding, Western sports, jumping, and middle-distance racing

PLACE OF ORIGIN

Western Washington state and eastern Idaho

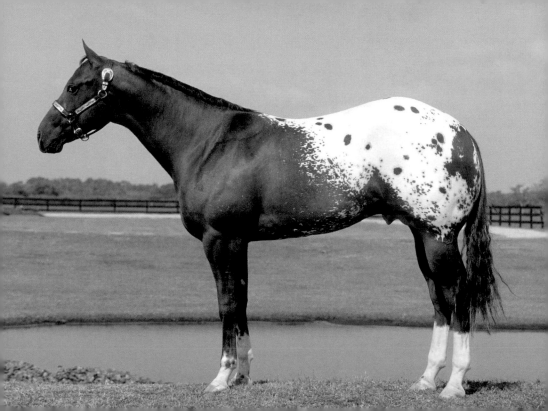

Arabian

Among the most beautiful of all horses, the Arabian is also one of the oldest recognizable types in the world. It is the most widespread breed on earth and the most influential, having been used to improve almost every other breed.

PONY

LIGHT HORSE

HEAVY HORSE

COLOR

HEIGHT: 14–15.3 hands

DESCRIPTION: Dished profile, large expressive eyes, wide forehead, small muzzle; arched neck, high tail carriage. Bay, gray, black, chestnut, or roan, always with black skin.

SPECIAL QUALITIES: Great beauty, tremendous endurance, high tail carriage, and unflagging spirit

BEST SUITED FOR: Endurance, pleasure riding, and showing

PLACE OF ORIGIN

Middle East, especially Iran, Iraq, Syria, Turkey, and Jordan

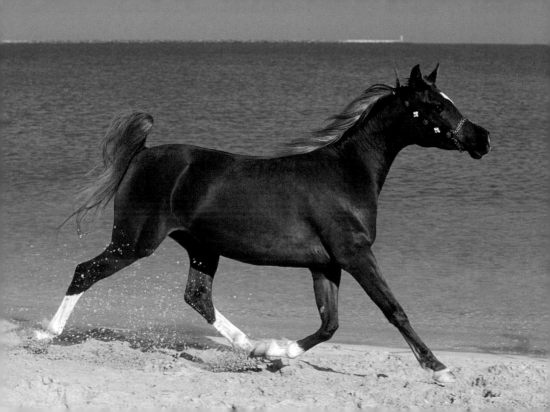

Azteca

A relatively new breed, the Azteca combines the finest qualities of its foundation breeds, the Andalusian, the Quarter Horse, and the Mexican Criollo: physical beauty combined with athletic ability and an ideal temperament.

HEIGHT: Male horses 15–16.1 hands, mares 14.3–16 hands

DESCRIPTION: Lean and elegant head, arched neck, small ears and intelligent eyes. All solid colors.

SPECIAL QUALITIES: Spirit, intelligence, agility, power, strength, elegance, and style

BEST SUITED FOR: Dressage, bull-fighting, reining, cutting, team penning, roping, polo, and pleasure riding

PLACE OF ORIGIN

Mexico

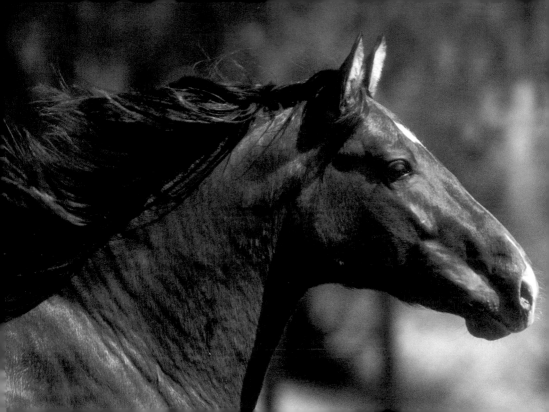

Belgian

Like all heavy horses, this breed descended from the Great Flemish Horse, which lived in northern Europe more than 2,000 years ago. The Belgian is said to have the quietest disposition of any of the draft breeds.

HEIGHT: 16–18 hands

DESCRIPTION: Can weigh up to 2,200 pounds; straight or slightly concave profile and small ears; deep body with broad, short back and massive croup; strong, lean legs with some feathering at fetlock; show types have longer legs than working types; large feet. Usually chestnut or sorrel with white mane and tail, four white stockings, and a blaze.

SPECIAL QUALITIES: Power and grace; high-stepping action; gentle temperament; easy keepers

BEST SUITED FOR: Draft and farm work; parade hitch

PLACE OF ORIGIN

Belgium

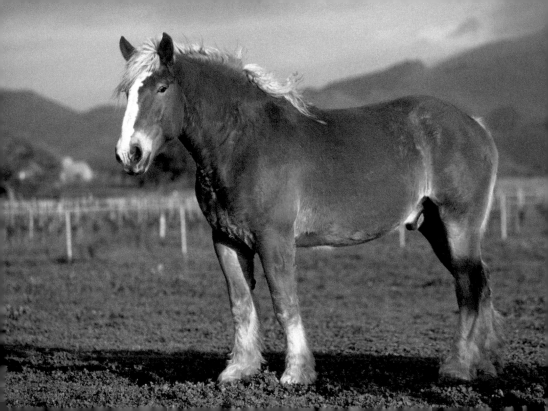

RARE

PONY

LIGHT
HORSE

HEAVY
HORSE

COLOR

Brabant

The powerful Brabant, the European version of the Belgian, is the heaviest of all the draft breeds. Although massive, these horses are easy keepers with a quiet, willing disposition, ideal for the small-scale farmer.

HEIGHT: 15.2–17 hands

DESCRIPTION: A large, neat head; short, heavily muscled neck; powerful, deep body supported by substantial legs; can weigh as much as 3,000 pounds. Most often red bay and bay roan, but blue and strawberry roans and solid dark bay are also found.

SPECIAL QUALITIES: Massively built; thicker-bodied and "draftier" than American Belgians; gentle disposition

BEST SUITED FOR: Farm work

PLACE OF ORIGIN

Belgium

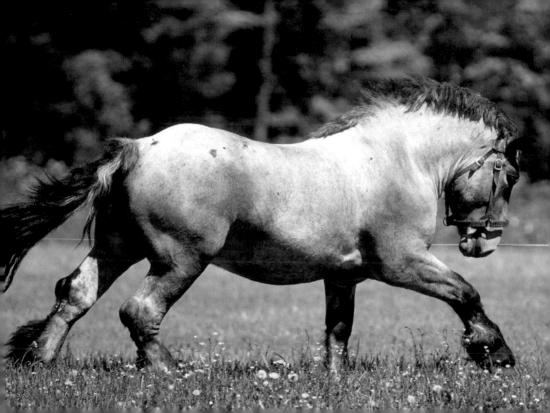

Buckskin

A light tan coat, black mane and tail, and black legs make a stunning combination on this buckskin. Most do not have a dorsal stripe. Seeming to symbolize the Old West, buckskin is a color, not a true breed.

COAT COLOR: Usually tan, but may range from cream to deep bronze

MANE AND TAIL: Black

SKIN: Dark

MARKINGS: Legs black from knees and hocks to ground; rarely, a dorsal stripe

RELATED COLORS: Dun

COLOR CLOSE-UP

Duns resemble buckskins but their hairs have dark pigment along one side. This gives the coat color a characteristic smuttiness, where other horses would have a sheen. In addition, duns often have darker points: a dorsal stripe, shoulder stripes, and zebra leg-stripes. The gene controlling these markings, called the dun factor, is often found in wild horses.

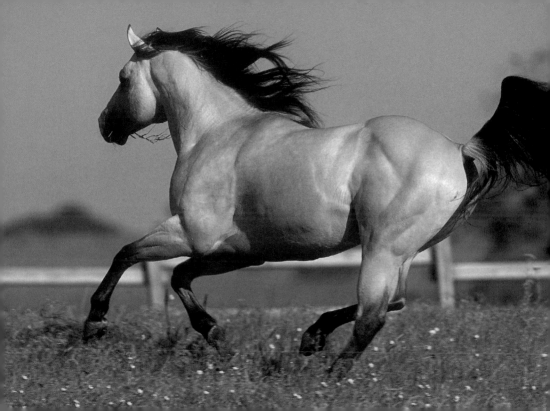

PONY

LIGHT
HORSE

HEAVY
HORSE

COLOR

Canadian Horse

Tracing its ancestry to the royal horses of French King Louis XIV, this breed has a long, illustrious history. It has contributed much to the development of Canada, as well as to many other breeds of horses.

HEIGHT: 14.3–16.2 hands

DESCRIPTION: Solidly built with strong, arched neck, long body; short head, wide between the eyes, with fine muzzle; long, wavy mane and high-set tail. Usually black or very dark brown.

SPECIAL QUALITIES: Hardy, sound, easy keeper

BEST SUITED FOR: Riding, jumping, and driving

PLACE OF ORIGIN

Quebec

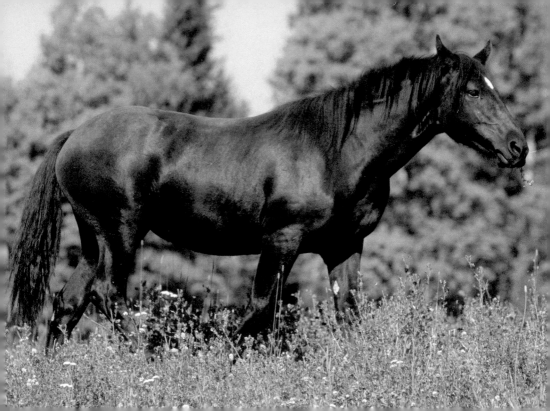

Canadian Sport Horse

Specifically developed to excel at the Olympic sports of show jumping, dressage, and eventing, this breed has big, fluid movement both on the flat and over jumps. Thoroughbred blood is evident in this stallion.

PONY

LIGHT HORSE

HEAVY HORSE

COLOR

HEIGHT: 16 hands and taller

DESCRIPTION: Well-balanced conformation; large, quiet eyes; straight movement and impulsion. Can be bay, brown, black, chestnut, gray, pinto, cremello, or palomino.

SPECIAL QUALITIES: An evolving breed of large, solid horses that are structurally correct and have fluid movement, excellent jumping talent, and a natural ability to work with their human partners

BEST SUITED FOR: Jumping, dressage, eventing, foxhunting, and driving

PLACE OF ORIGIN

Canada, especially Ontario

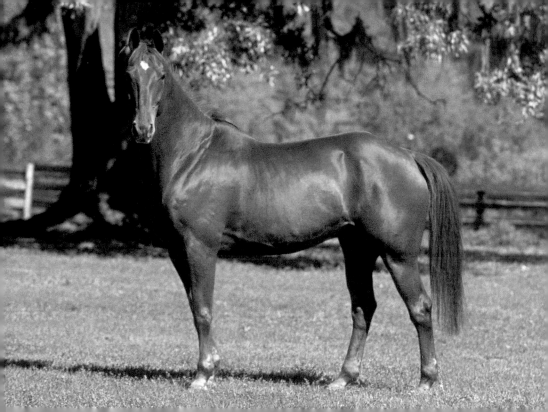

Caspian

This very old breed is closely related to the Arabian and may be an ancestor of today's hot-bloods. Exceptionally gentle, Caspians show superb jumping ability and still, as in ancient times, make excellent driving animals.

PONY

LIGHT HORSE

HEAVY HORSE

COLOR

HEIGHT: 10–12 hands

DESCRIPTION: Delicate-looking and beautiful but extremely tough and durable; short head with short ears, small muzzle; pronounced withers. Most often bay but can be chestnut, black, gray, dun; never spotted.

SPECIAL QUALITIES: Small, beautiful, fine-boned, tractable horses of surprising strength and athleticism

BEST SUITED FOR: Driving, jumping; elegant and reliable children's mounts

PLACE OF ORIGIN

A very ancient breed rediscovered in northern Iran in 1965

40

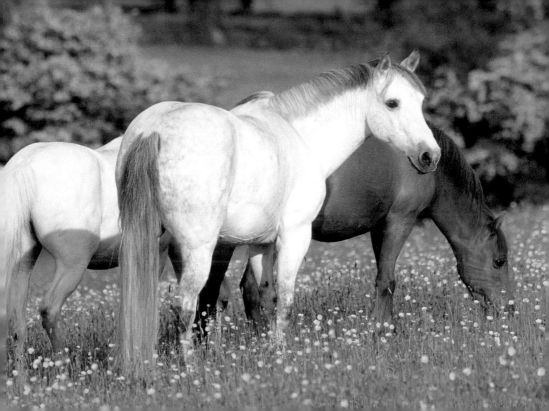

PONY

LIGHT
HORSE

HEAVY
HORSE

COLOR

gaited

Cerbat

Many individuals in this breed have smooth, lateral gaits. Most likely, the Cerbat arose from horses that escaped from or were lost by the early Spanish expeditions into the American Southwest. Cerbats are unusually long-lived.

HEIGHT: 13.2–14.2 hands

DESCRIPTION: High-set eyes, small, curved ears, and straight profile; deep heart girth. Usually bay, chestnut, or red roan.

SPECIAL QUALITIES: A critically rare breed of surefooted, tough, athletic horses; conformation is representative of Spanish Colonial Horses; some are gaited

BEST SUITED FOR: Endurance, trail riding, ranch work, and pleasure riding

PLACE OF ORIGIN

Northwestern Arizona; genetic heritage goes back to the early Spanish horses

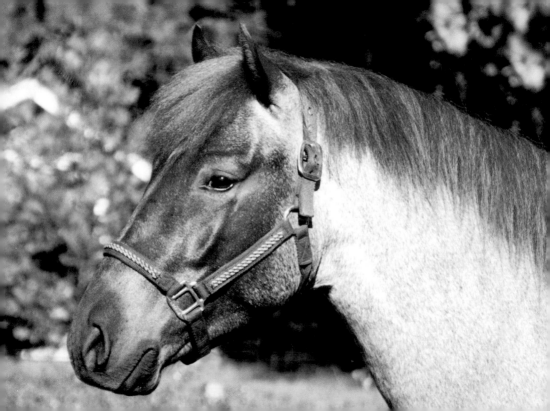

PONY

LIGHT
HORSE

HEAVY
HORSE

COLOR

Chincoteague Pony

This little herd of tough, hardy ponies has survived the harsh conditions on the coastal islands of Assateague and Chincoteague for hundreds of years. Older foals are auctioned every year after a roundup.

HEIGHT: 13.2–14.2 hands

DESCRIPTION: Pretty faces with straight or slightly dished profile, small muzzle, and large soft eyes; tipped-in ears; well-angulated shoulders; thick mane and tail; rounded croup and low-set tail. All solid colors and many pintos.

SPECIAL QUALITIES: Famous from the books of Marguerite Henry and as fund-raisers for the volunteer fire department of Chincoteague, VA

BEST SUITED FOR: Pleasure riding, hunter events, driving, trail riding; ideal first mounts for children

PLACE OF ORIGIN

Assateague Island, Virginia; original stock possibly from Spain

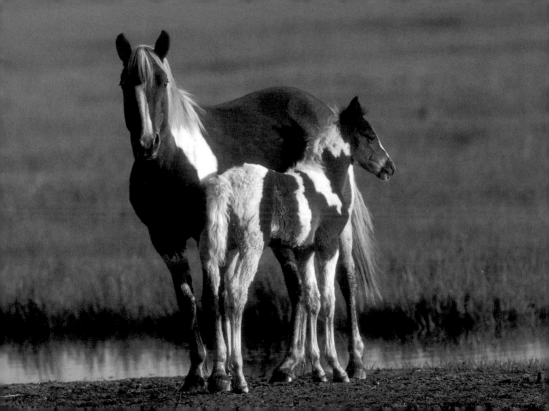

PONY

LIGHT HORSE

HEAVY HORSE

COLOR

Cleveland Bay

One of the greatest and oldest of England's native breeds, the Cleveland Bay includes only about 500 purebred horses throughout the world. This horse demonstrates the calm, kind, assured expression characteristic of the breed.

HEIGHT: 16–16.2 hands

DESCRIPTION: Bold head with convex profile; long, lean neck; deep, wide body. Always true bay with black points and no white other than a very small star.

SPECIAL QUALITIES: A critically rare breed; demonstrates great uniformity in color, type, and quality; has long been used for the improvement of other breeds

BEST SUITED FOR: Field and show hunters, dressage, combined driving, improvement of other breeds

PLACE OF ORIGIN

Yorkshire, England

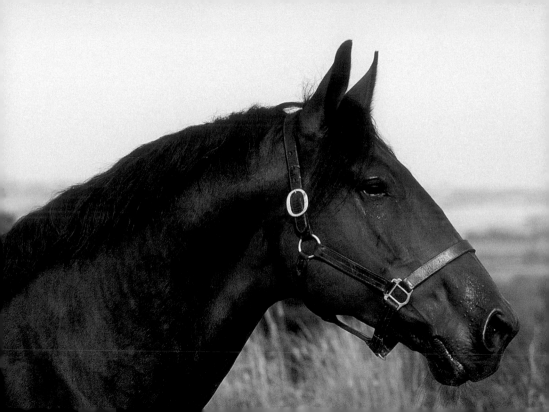

PONY

LIGHT
HORSE

HEAVY
HORSE

COLOR

Clydesdale

These grand horses are the pride of Scotland. The breed dates back to the mid-18th century, when local mares were crossed on Flemish stallions. Handsome, weighty, and powerful, they have a unique gaiety of carriage.

HEIGHT: 16.2–18 hands

DESCRIPTION: Broad forehead with flat profile, big ears, and wide muzzle; long, arched neck and high withers; short back; long pasterns and wide feet; long, silky feathering from knee or hock to fetlock. Usually bay or brown; also roan, black, gray and, rarely, chestnut; usually with white face and leg markings.

SPECIAL QUALITIES: Long silky feathering on the lower legs that highlights exceptionally fluid and powerful movement

BEST SUITED FOR: Multi-horse hitches, draft work

PLACE OF ORIGIN

Scotland

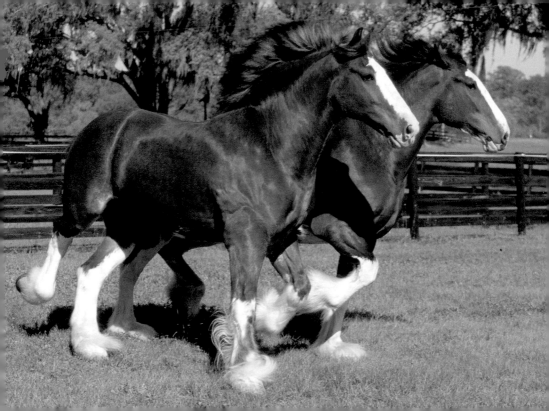

Colorado Rangerbred

Bred to be ranch horses, Rangerbreds still maintain strong working abilities and athleticism combined with an easy disposition. They are now used mostly as pleasure, trail, and show horses in both Western and English events.

HEIGHT: 14.2–16 hands

DESCRIPTION: Well-shaped head; long, muscular neck; moderately pronounced withers, deep chest, and slightly sloping croup. Although many of the horses are Appaloosa, they do not have to be. All solid colors are found in the breed. Pintos do not occur.

SPECIAL QUALITIES: Excellent endurance, athleticism, and "cow sense"; some individuals exhibit the leopard-complex genes (Appaloosa coloring)

BEST SUITED FOR: Ranch work, pleasure and trail riding, and all Western events

PLACE OF ORIGIN

The high plains of eastern Colorado

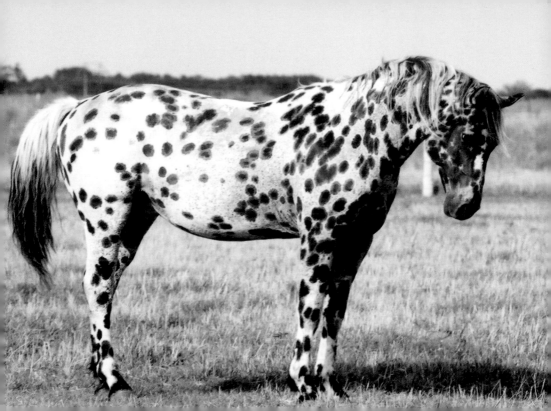

Connemara Pony

Ponies have run free on the rugged western coast of Ireland since ancient times. The rough, rocky environment made them hardy, agile, and intelligent. Modern Connemaras are sensible, cool-headed, and outstanding jumpers.

HEIGHT: 13–14.2 hands

DESCRIPTION: Well-shaped head with straight profile, small ears, and large eyes; long neck with full mane and pronounced withers; long back with slightly sloping croup. Most often gray or dun, but also black, bay, brown, palomino, chestnut, and occasionally roan or dark-eyed cream.

SPECIAL QUALITIES: Hardiness, stamina, great jumping talent

BEST SUITED FOR: Jumping, hunting, dressage, eventing, driving, trail riding, and even light draft work; also make ideal children's mounts

PLACE OF ORIGIN

Western Ireland

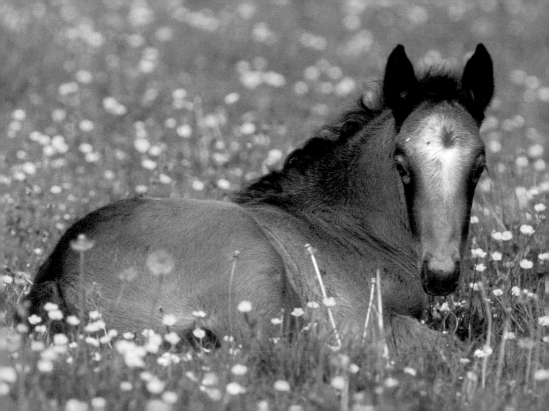

PONY

LIGHT
HORSE

HEAVY
HORSE

COLOR

Dales Pony

Originally bred to work as packhorses in lead mines, today Dales Ponies can be seen in a variety of equine endeavors, including dressage, driving, and trail riding. They are highly valued for their excellent, energetic movement.

HEIGHT: 14–14.2 hands

DESCRIPTION: Head broad between the eyes with long forelock; long, strong neck with well laid-back shoulders; short-coupled body and deep hindquarters; ample mane and very long, medium-set tail. Usually black or brown; sometimes gray or roan; occasionally a star or snip on face or white on hind fetlocks.

SPECIAL QUALITIES: Sturdiness, tractability, excellent gaits

BEST SUITED FOR: Dressage, hunting, trail riding, driving; ideal first mount for a child

PLACE OF ORIGIN

Northern England

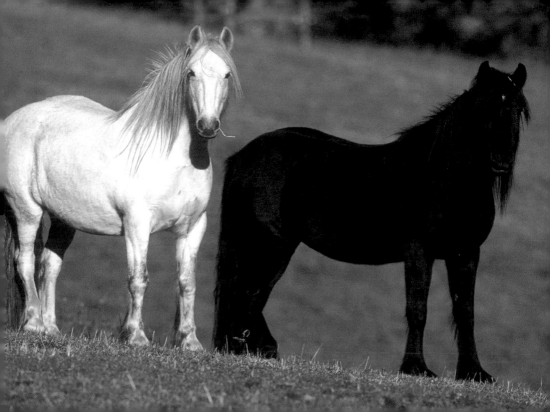

PONY

LIGHT
HORSE

HEAVY
HORSE

COLOR

Dartmoor Pony

Almost 1,000 years old, this breed hauled carts in the tin mines of Dartmoor for centuries. Surefooted, quiet, and gentle, these ponies are versatile, excelling at both jumping and driving, with straight, free, fluid action.

HEIGHT: 12–12.2 hands

DESCRIPTION: Small, well-set head with prominent eyes, small ears, and large nostrils; strong neck and sloping shoulders; shaggy coat; very full, high-set tail. Usually bay, brown, or back; occasionally gray or chestnut.

SPECIAL QUALITIES: A rare breed; world population of only 5,000 to 7,000 animals, with fewer than 100 in North America

BEST SUITED FOR: First mounts for children; jumping and driving

PLACE OF ORIGIN

Southwestern England

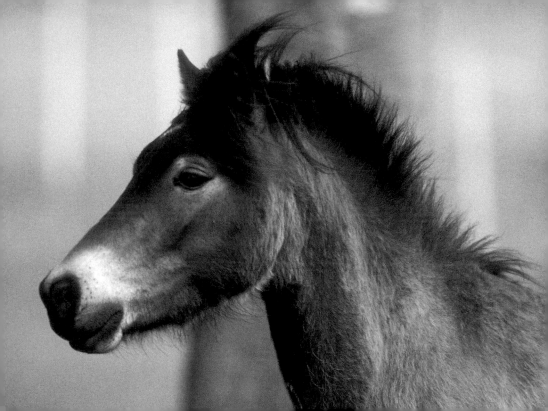

Donkeys

Their intelligence, agility, and hardiness have made donkeys an important part of human history. They are still used in many parts of the world as pack, driving, and draft animals.

PONY

LIGHT HORSE

HEAVY HORSE

COLOR

HEIGHT: Ranges from miniature (36" and under) to mammoth and Poitou (15–16 hands)

DESCRIPTION: Long head, large eyes, and very long ears; short, upright neck and flat withers; angular body with narrow chest and flat sides; small, narrow feet; spare upright mane and cowlike tail. Most often black, gray, and white; light muzzle and eye rings; often a dorsal stripe, shoulder stripes, and leg bars.

SPECIAL QUALITIES: Long ears and narrow but deep body frame to aid in heat dissipation; surefooted, very strong for size; generally placid

BEST SUITED FOR: Packing, pulling, companionship, and guarding flocks

PLACE OF ORIGIN

Nubia (Sudan), North Africa

Dutch Warmblood

Well made and powerful, Dutch Warmbloods are often found on the rosters of the most elite jumping and dressage horses in the world. They are known for their tractable disposition and powerful movement.

HEIGHT: 15.2–17 hands, average is about 16.1

DESCRIPTION: Well-shaped head with straight profile; arched, muscular neck; prominent withers and deep chest; short flat croup; powerful hindquarters. Usually chestnut, bay, black, or gray, often with white facial and leg markings.

SPECIAL QUALITIES: World-famous for their athletic ability

BEST SUITED FOR: Jumping, dressage, and driving

PLACE OF ORIGIN

Holland

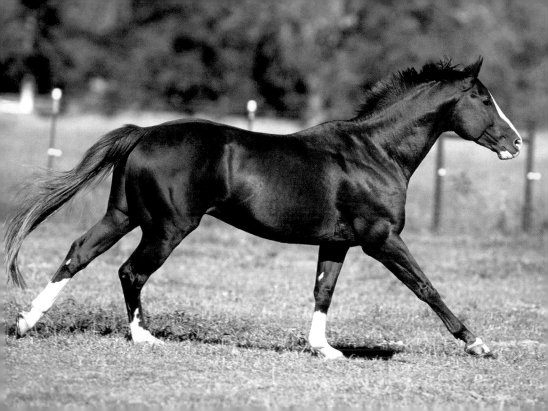

PONY

LIGHT
HORSE

HEAVY
HORSE

COLOR

Exmoor Pony

Fossils show that a pony much like the Exmoor was widespread on earth a million years ago. Today's Exmoor Ponies all descend from animals raised wild on the English moors, and they are all nearly identical to one another.

HEIGHT: 11.2–12.3 hands

DESCRIPTION: Stocky and strong, with deep chest and large girth; short, pointed ears; prominent eyes with a fleshy hood and pale outline; short legs. Always brown with darker legs and oatmeal ("mealy") color on muzzle and around eyes.

SPECIAL QUALITIES: Water-repellent winter coat with coarse, greasy outer hair covering a soft, springy undercoat

BEST SUITED FOR: Children's mounts, driving, endurance, and work with disabled

PLACE OF ORIGIN

The remote moors of southwestern England

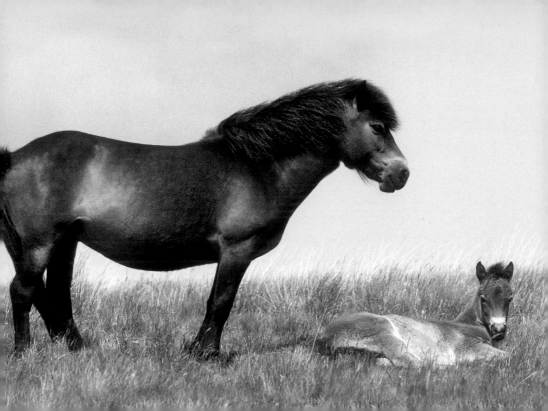

Fell Pony

The influence of its Friesian ancestry can be seen in the handsome Fell Pony. Versatile and attractive, this breed is athletic, tough, kind, and intelligent. Fells have excellent gaits and are good jumpers.

HEIGHT: Average height 13.2 hands; maximum allowed is 14 hands

DESCRIPTION: Small, well-chiseled head with straight profile and broad forehead and nose; prominent eyes and small ears; strong neck, well laid-back shoulders, and thick body; heavy, full mane and tail; short, sloping croup with medium to low tail set. Black, brown, bay, or gray, with minimal white markings.

SPECIAL QUALITIES: Surefooted, gentle, excellent gaits and stamina, and compact but can carry an adult

BEST SUITED FOR: Trail riding, driving, and jumping

PLACE OF ORIGIN

Northern England

PONY

LIGHT HORSE

HEAVY HORSE

COLOR

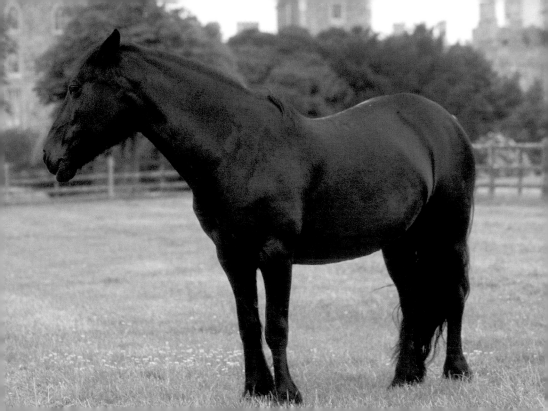

RARE

PONY

LIGHT HORSE

HEAVY HORSE

COLOR

gaited

66

Florida Cracker

Early American drovers that rode small horses and cracked whips to move their cattle inspired this breed's name. Crackers are naturally gaited, and all gaits are ground covering, comfortable, and easy for both horse and rider.

HEIGHT: 13.2–15 hands

DESCRIPTION: Small, comfortable horses, exceptionally quick and agile; straight or convex profile; neck about same length as distance from withers to croup; sloping croup and medium to low tail set. All colors, especially bay, brown, black, and gray.

SPECIAL QUALITIES: An extremely rare breed of gaited horses with excellent "cow sense"

BEST SUITED FOR: Ranch work, endurance, trail riding, team penning, and team roping

PLACE OF ORIGIN

Southeastern United States; descended from early Spanish horses

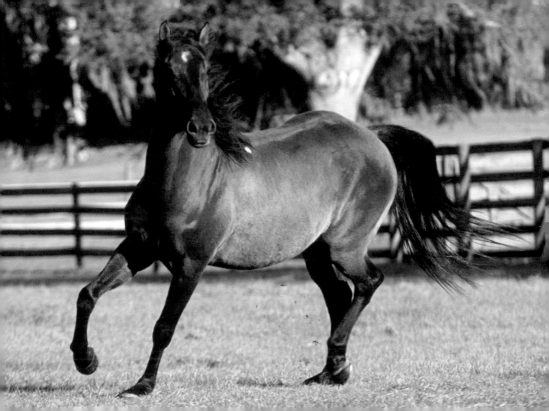

Friesian

The silhouette of a Friesian is virtually unmistakable, with a noble head set on a long, gracefully arched neck as well as feathering on the lower legs. The mane and tail are always full and abundant.

HEIGHT: 15–17 hands

DESCRIPTION: A well-constructed horse of strength and luxuriance with a compact build; relatively small head with flat profile and swanlike neck, carried high; slightly sloping croup; feathering on hooves; abundant mane and tail. Always black, occasionally with a small white star.

SPECIAL QUALITIES: Striking profile, regal bearing, solid black color

BEST SUITED FOR: Driving, dressage, and elegant pleasure riding

PLACE OF ORIGIN

The area along the coast of the North Sea once known as Friesland, from present-day Netherlands to Denmark

PONY

LIGHT HORSE

HEAVY HORSE

COLOR

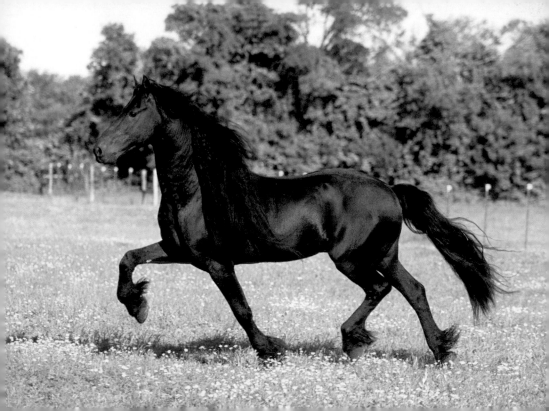

Galiceno

This very old and rare breed of attractive small horses is not well known in most of North America. Smooth-gaited and agile, Galicenos form exceptionally strong bonds with their human companions.

HEIGHT: 12–14.1 hands

DESCRIPTION: Pony-sized; head with good width between eyes, small muzzle, and pointed ears; thick mane often lying on both sides of arched neck; prominent withers and well-sloped shoulders; slightly sloped croup and low tail set; long, full tail. All solid colors other than albino.

SPECIAL QUALITIES: A very rare breed of gaited, pony-sized horses with the character, presence, courage, and stamina of other Spanish breeds

BEST SUITED FOR: Trail and endurance riding, cutting, and reining

PLACE OF ORIGIN

Northwestern Spain

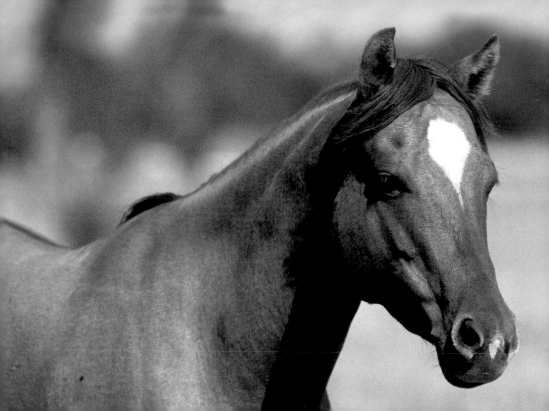

RARE

PONY

LIGHT
HORSE

HEAVY
HORSE

COLOR

Gotland Pony

Originally associated with the ancient Goths, this very old breed has changed very little over the centuries. Gotlands are excellent movers and can maintain their ground-covering trot with ease for a remarkably long time.

HEIGHT: 12–14 hands

DESCRIPTION: Straight or dished profile with small ears, broad forehead, and wide-set eyes; short muscular neck, pronounced withers, long back, and slightly sloping croup; full mane and tail and exceptionally dense winter coat. Commonly gray dun, liver dun, buckskin, and black, often with a dorsal stripe.

SPECIAL QUALITIES: An ancient but now rare breed of stocky ponies characterized by their "primitive" color and markings

BEST SUITED FOR: Driving, jumping, and children's pleasure mounts

PLACE OF ORIGIN

Gotland, Sweden

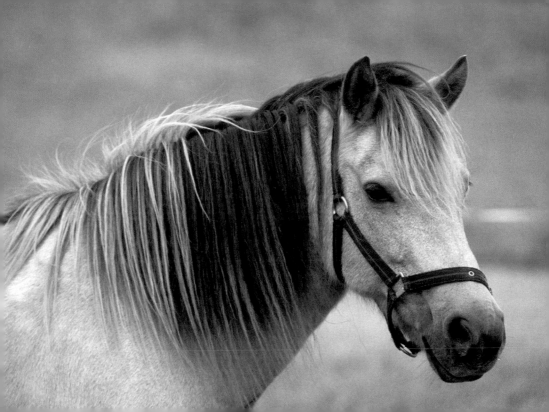

Gypsy Vanner

Developed over generations by Gypsy breeders in England, Vanners are the perfect caravan horse: strong, intelligent, docile, colorful, and sound. They have excellent gaits and an easygoing temperament.

PONY

LIGHT HORSE

HEAVY HORSE

COLOR

HEIGHT: 14–15.2 hands

DESCRIPTION: Compact, strong cobs; abundant manes and tails and heavy leg feathering. Often pintos, but solid colors also occur.

SPECIAL QUALITIES: Striking appearance; excellent gaits; willing, docile disposition; rounded withers suitable for riding and harness; broad backs make them excellent bareback mounts

BEST SUITED FOR: Driving, pleasure riding, and dressage

PLACE OF ORIGIN

England

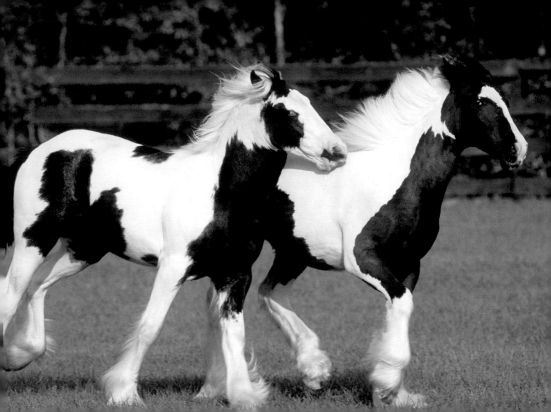

Hackney Horse

Solidly built with sloping shoulders and strong legs, Hackneys have good gaits but were born to trot. Though best known for their action in harness, they also make fine riding horses and excellent jumpers.

HEIGHT: 14.2–16 hands

DESCRIPTION: Small head, muzzle, and ears; long neck and broad chest; compact body with sloping shoulders, level croup, and high tail set. Black, brown, bay, or chestnut, sometimes with white facial and leg markings.

SPECIAL QUALITIES: Driving horses of substance, soundness, and endurance famous for their spectacularly high ground-covering motion

BEST SUITED FOR: Driving, jumping, and improvement of other breeds

PLACE OF ORIGIN

England

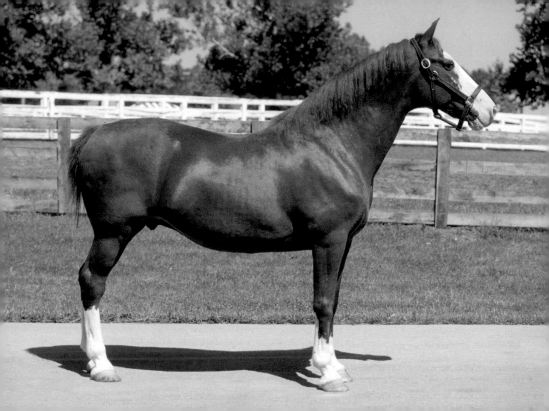

Hackney Pony

In the 1870s trotting breeds were combined with Fell and Welsh ponies to produce this breed. Known primarily for outstanding action under harness, the Hackney Pony also performs well in English and Western competition.

PONY

LIGHT HORSE

HEAVY HORSE

COLOR

HEIGHT: 12.2–14.2 hands

DESCRIPTION: Light, long head with straight or slightly convex profile, large eyes, and small ears; arched neck and sloping shoulders; short back and long croup with high tail set. Usually bay, brown or black; occasionally chestnut, roan, or gray; minimal white markings.

SPECIAL QUALITIES: Effervescent ponies of great presence with brilliant high action and excellent stamina

BEST SUITED FOR: Fine harness, pleasure and roadster driving, hunter-jumper, trail, eventing, and Western competition

PLACE OF ORIGIN

Northern England

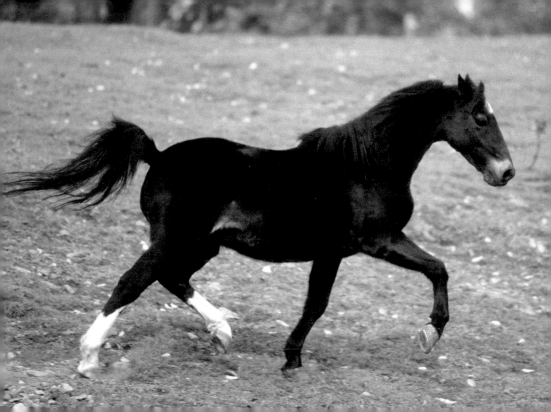

PONY

LIGHT
HORSE

HEAVY
HORSE

COLOR

Haflinger

The sixth-century Ostrogoths created this breed by crossing Arabians with Alpine ponies. Austrians call them "princes in front, peasants behind," because they have beautiful heads and muscular hindquarters.

HEIGHT: 13–15 hands

DESCRIPTION: Solid, yet elegant and refined; small head often showing Arab influence; slightly sloping croup. Always chestnut, ranging from rich gold to chocolate, with flaxen to white mane and tail.

SPECIAL QUALITIES: Attractive, sturdy, small, exceptionally long-lived horses with an excellent disposition; rhythmic, ground-covering gaits

BEST SUITED FOR: Driving; pleasure riding, packing; farm work; lower-level dressage; eventing and jumping; all-around family horse

PLACE OF ORIGIN

The Tyrol region of Austria and Italy

Hanoverian

Descended from powerful German military and farm horses, Hanoverians are world-class athletes, winning numerous Olympic medals, and are the world's most popular warmblood breed.

HEIGHT: 16–17.2 hands

DESCRIPTION: Good bone and muscle in proportion to size; straight profile; long, muscular neck; powerful shoulders and hindquarters. Typically chestnut, but also bay, brown, black, and gray.

SPECIAL QUALITIES: Spectacular movement, tremendous athletic ability

BEST SUITED FOR: Show jumping, dressage, combined driving, show and field hunters

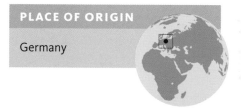

PLACE OF ORIGIN

Germany

Holsteiner

Until machines took over, this breed had been developed to pull coaches, artillery, and plows. Today, through careful breeding, the Holsteiner has become a superb athlete excelling in high-level competition.

HEIGHT: 16–17 hands

DESCRIPTION: Bold, expressive face; large and deep-bodied, with short, flexible back; abundant bone. Usually brown, black, and bay, often with white on face and lower legs.

SPECIAL QUALITIES: Power, excellent gaits, tremendous jumping ability, striking good looks and bold action

BEST SUITED FOR: Dressage, show jumping, and combined driving

PLACE OF ORIGIN

Germany

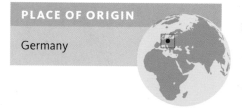

PONY

LIGHT HORSE

HEAVY HORSE

COLOR

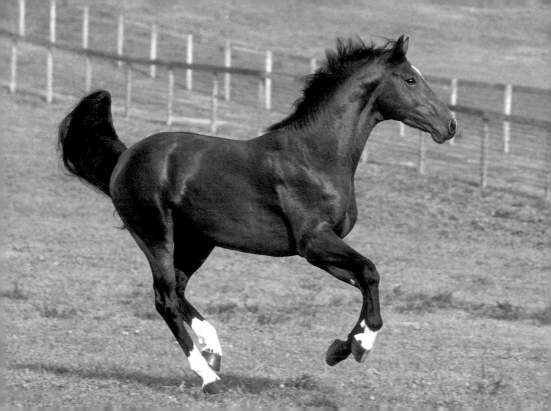

Hungarian Horse

Hungary has a long history of fine horse-breeding, dating from the ninth-century Magyar tribesmen. Modern Hungarian Horses are known to be excellent, sometimes spectacular, movers and outstanding jumpers.

HEIGHT: 15.3–17 hands

DESCRIPTION: Powerful but not massive; well-shaped head with good width between eyes; kind, alert expression; long neck set on sloping shoulders, prominent withers and deep chest; rounded croup and fairly high tail set. Any solid color, including palomino and buckskin.

SPECIAL QUALITIES: Outstanding athletic ability, excellent gaits

BEST SUITED FOR: Show jumping, dressage, eventing, and combined driving

PLACE OF ORIGIN

Hungary

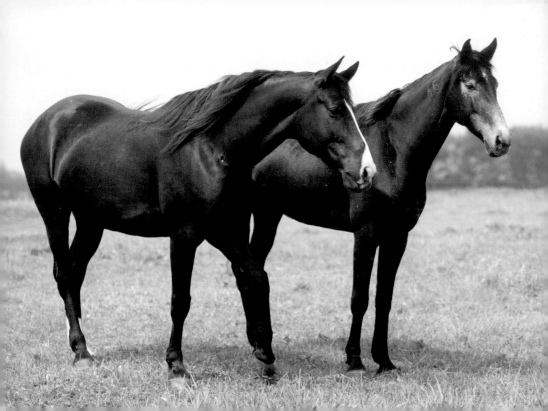

PONY

LIGHT
HORSE

HEAVY
HORSE

COLOR

gaited

88

Icelandic Horse

These tough, smooth-gaited horses are virtually identical to the ones that arrived in Iceland with the Vikings more than 1,000 years ago. Since then there has been no admixture of other breeds. Some Icelandics are five-gaited.

HEIGHT: 12.2–14.3 hands

DESCRIPTION: Rectangular and well-proportioned; expressive head with straight profile; long neck set on sloping shoulders; wide, muscular croup. All colors and patterns known to horses, as well as some unique to this breed.

SPECIAL QUALITIES: A small gaited breed with the strength and stamina to carry adults; known for its very fast and extremely smooth gait, the *tolt*

BEST SUITED FOR: Trail riding, trekking, and endurance

PLACE OF ORIGIN

Iceland, with genetic contributions from the horses of the Vikings and Celts

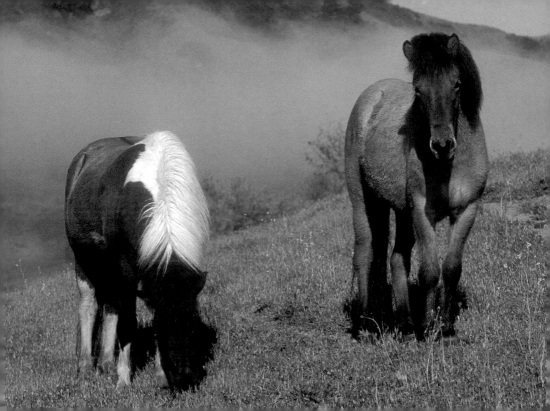

Irish Draught

The Irish Draught is a proud, powerful horse of substance and quality, known for its gentle nature and superb jumping ability. When crossed on Thoroughbreds this breed has produced some of the world's best show jumpers.

HEIGHT: 15.2–17 hands

DESCRIPTION: Usually tall; well-shaped head with flat profile, wide forehead, and long ears; high-set neck, well-defined withers, and deep heart girth; slightly sloping croup; no feathering but silky hair at back of fetlocks. All solid colors, especially gray and chestnut, often with white markings on face and lower legs.

SPECIAL QUALITIES: Consistency of type, excellent gaits, gentle disposition, jumping talent

BEST SUITED FOR: Jumping, hunting, driving, dressage, eventing, and improvement of other breeds

PLACE OF ORIGIN

Ireland

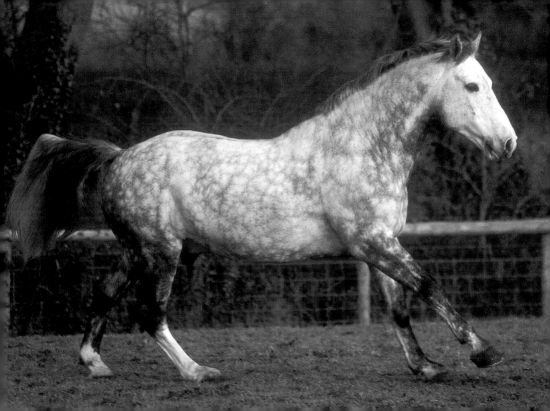

PONY

LIGHT
HORSE

HEAVY
HORSE

COLOR

gaited

92

Kentucky Mountain Saddle Horse

Developed by farmers in the hills of eastern Kentucky, these small, powerful horses probably trace back to the early Narragansett Pacer of Colonial times. Ideal for trail riding, they are gentle, comfortable pleasure mounts.

HEIGHT: 11–15.2 hands

DESCRIPTION: A small, sturdy, gentle, smooth-gaited, easy-keeping horse; bold eyes and flat profile; wide, deep chest; ample mane and tail. All solid colors.

SPECIAL QUALITIES: Small to medium, attractive, gaited horses known for surefootedness, stamina, and their ability to carry riders safely and comfortably over extremely rough ground

BEST SUITED FOR: Trail riding, all-around family horses, and small-scale farming

PLACE OF ORIGIN

Eastern Kentucky

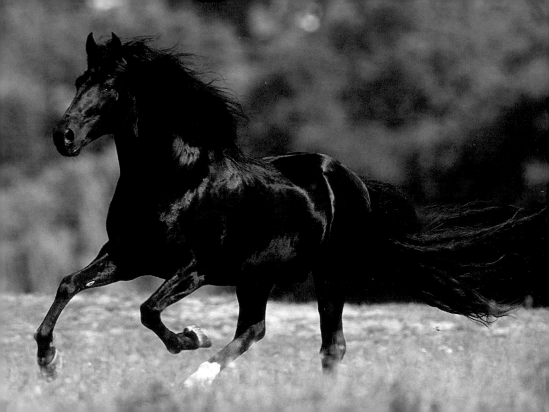

RARE

PONY

LIGHT
HORSE

HEAVY
HORSE

COLOR

Kerry Bog Pony

Strong, smart, and athletic, Kerry Bogs make good sport ponies for young riders, an excellent choice for people with physical limitations, and wonderful driving ponies and companion animals for adults.

HEIGHT: 10–11 hands

DESCRIPTION: Elegant; slightly dished profile, small ears, and large eyes; deep chest and short back; steep hoof angle and upright pasterns; dense winter coat. All solid colors, many with flaxen manes and tails; often with white face and lower-leg markings.

SPECIAL QUALITIES: Gentle, sure-footed ponies with slightly flashy, straight, level action, good balance, and excellent stamina; well adapted for work on marshy ground

BEST SUITED FOR: Child's first mount, children's sport pony, driving, and work with disabled

PLACE OF ORIGIN

Ireland

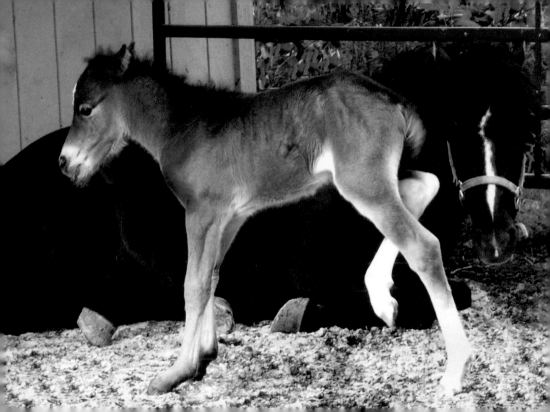

RARE

PONY

LIGHT
HORSE

HEAVY
HORSE

COLOR

Kiger Mustang

Closely related to the early Spanish horses, this breed of wild mustangs was first discovered in 1977, surviving in the mountains of remote southeastern Oregon. Today the Bureau of Land Management manages the small herd.

HEIGHT: 14–15 hands

DESCRIPTION: Classic Spanish head with flat or slightly convex profile; high, almond-shaped eye; pronounced withers, short back, and slightly sloped croup with low-set tail. Always dun, grulla, or buckskin, in many shades; dorsal stripes; occasional zebra striping on legs, and cobweb markings on forehead.

SPECIAL QUALITIES: Spanish conformation, may be gaited

BEST SUITED FOR: Working cattle; endurance, trail and pleasure riding

PLACE OF ORIGIN

Discovered in the Kiger Gorge on Steens Mountain of eastern Oregon, but genetic heritage goes back to the early Spanish horses and the ancient Sorraia of Iberia

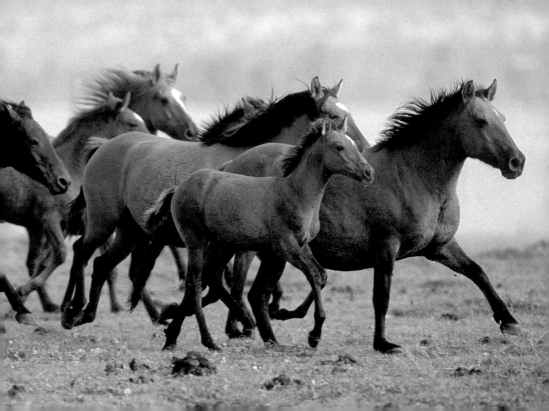

RARE

PONY

LIGHT
HORSE

HEAVY
HORSE

COLOR

Lac La Croix Indian Pony

Rescued from the brink of extinction in the late 1970s, this breed may be a descendant of the Canadian Horse and the Spanish Mustang. The ponies have a comfortable trot and canter, great stamina, intelligence, and curiosity.

HEIGHT: Mares 12–12.3 hands; males 12.3–13.2 hands

DESCRIPTION: Small, with a broad, tapering head; small, profusely haired ears, and nostrils with flaps to keep out bad weather; large cannons with slight feathering; abundant mane, forelock, and tail; low withers, straight back, and sloping croup with low-set tail. Any solid color except palomino, white, or cream; usually bay, black, grullo, or dun.

SPECIAL QUALITIES: Known for surefootedness, cleverness, tractability, and tolerance of human beings

BEST SUITED FOR: Driving, riding, packing; work with beginning and disabled riders

PLACE OF ORIGIN

Ojibwa Nation, especially Minnesota and northern Ontario

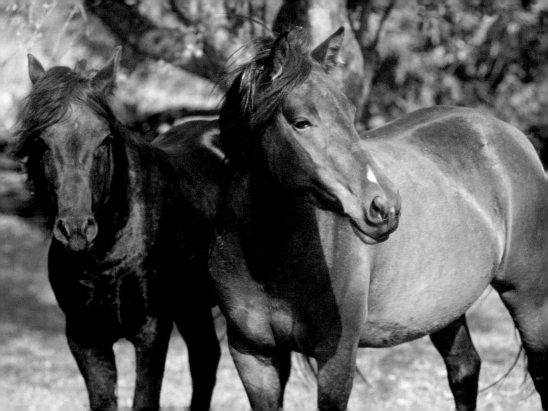

Lipizzan

Lipizzans are best known for their history in dressage, but in North America they are now sometimes seen in jumping classes and at lower-level events. They resemble the very best Spanish horses of Columbus's time.

PONY

LIGHT HORSE

HEAVY HORSE

COLOR

HEIGHT: 15–15.3 hands

DESCRIPTION: Small, elegant, and proud; long head with great character and straight or slightly convex profile; high knee action; arched neck, flat withers, and long back; short, slightly sloped croup with high tail set. Nearly always gray; occasionally black or bay.

SPECIAL QUALITIES: Uniformity of type; faces of great character; remarkable talent for classical dressage

BEST SUITED FOR: Dressage, pleasure riding, and driving

PLACE OF ORIGIN

Developed in Lipizza, formerly in Austria but now in Slovenia, from Spanish bloodlines

PONY

LIGHT
HORSE

HEAVY
HORSE

COLOR

Lusitano

The Lusitano is the most popular riding horse in Portugal, highly valued for its gentle disposition, splendid appearance, and excellent gaits. Closely related to the Andalusian, the Lusitano has natural "cow sense."

HEIGHT: 15–16 hands

DESCRIPTION: Strong and muscular with a wide chest and a short back; elegant head with straight or slightly convex profile; arched neck. Solid colors only, including bay, gray, black, and chestnut.

SPECIAL QUALITIES: Exceptionally even temperament, elegance, agility, power, "cow sense"

BEST SUITED FOR: Dressage, all general riding purposes, ranch and cattle work, and mounted bullfighting

PLACE OF ORIGIN

Portugal

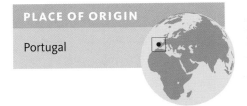

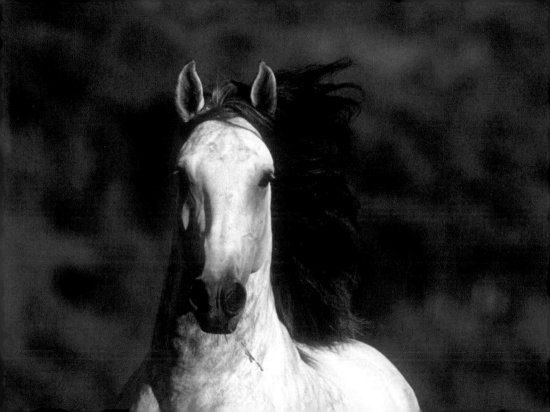

PONY

LIGHT
HORSE

HEAVY
HORSE

COLOR

gaited

104

Mangalarga Marchador

When Napoleon advanced on Portugal in 1807, the royal family escaped to Brazil, taking some of the country's finest horses with them. There breeders developed the exceptional Mangalarga, now the national horse of Brazil.

HEIGHT: 14.3–15.2, averaging 15 hands

DESCRIPTION: Triangular head with large flat forehead, fine muzzle, and flat (not concave) profile; ears with inward-turning tips; long, slightly sloping croup with medium tail set. Most often bay, gray, or chestnut.

SPECIAL QUALITIES: Smooth *marcha* gait with moments when three legs support the horse; tremendous endurance; *brio,* a regal, spirited bearing

BEST SUITED FOR: Ranch work; endurance; trail and pleasure riding; good choice for riders with back or knee pain

PLACE OF ORIGIN

Developed in Brazil, but the ancestral bloodlines are from Portugal

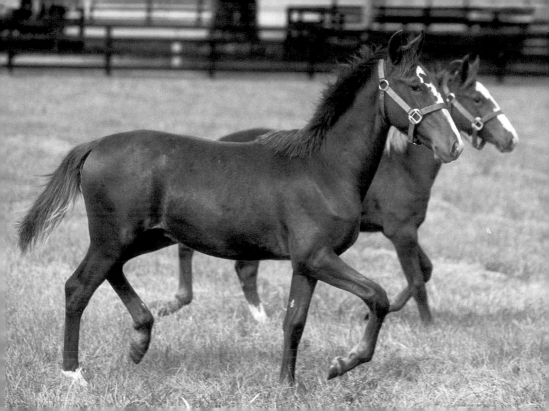

RARE

PONY

LIGHT
HORSE

HEAVY
HORSE

COLOR

Marwari

Well designed for the desert, these sturdy horses have fine skin to radiate heat and long eyelashes to protect their eyes from sandstorms. Their unique, inwardly hooked, lyre-shaped ears sometimes touch, forming a perfect arch.

HEIGHT: 14.2–15.2 hands

DESCRIPTION: Compact body with upright shoulder; long legs; head with prominent eyes and straight or slightly Roman profile; ears pointing inward at tips; high-set neck; long croup with high tail set. Gray most valued; also comes in pinto and all solid colors except chestnut.

SPECIAL QUALITIES: An extremely rare breed with a bold, arrogant presence and scimitar-shaped, hooked ears; some individuals are gaited

BEST SUITED FOR: Endurance riding, spirited pleasure riding, and dressage

PLACE OF ORIGIN

Northwest India

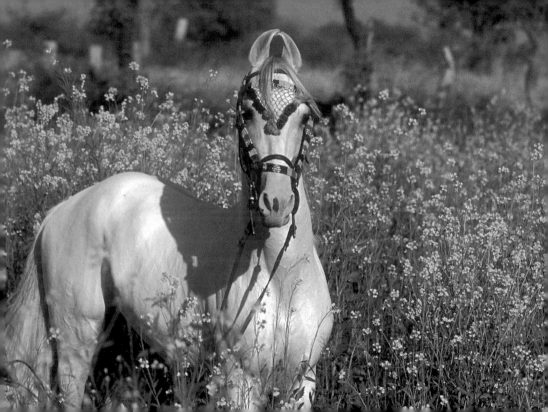

McCurdy Plantation Horse

Just after the Civil War, the McCurdy brothers of central Alabama bred these smooth-gaited, tractable, durable, versatile horses, many with natural "cow sense." Their smooth four-beat gait is called the McCurdy Lick.

HEIGHT: 14.2–16 hands

DESCRIPTION: Generally refined in appearance; broad chest, short back, and rounded hips; heavy mane and tail. Often gray, but also chestnut, sorrel, bay, black, and red and bay roans; often with white on face and below knees.

SPECIAL QUALITIES: A gaited horse, specializing in the "McCurdy Lick," a four-beat, single-footing gait; other gaits are the flat walk, the running walk, the natural rack, and the stepping pace

BEST SUITED FOR: Trail and pleasure riding, following hunts, and field trials

PLACE OF ORIGIN

Alabama

PONY

LIGHT HORSE

HEAVY HORSE

COLOR

gaited

108

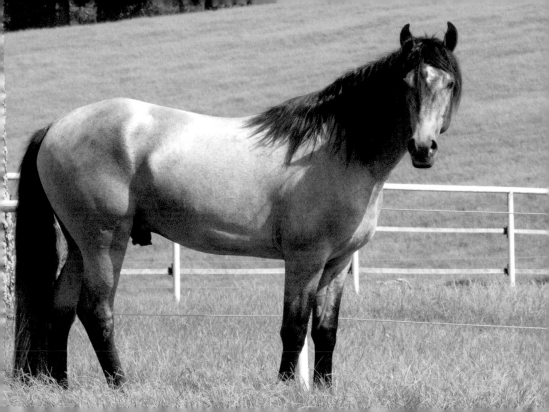

PONY

LIGHT
HORSE

HEAVY
HORSE

COLOR

Miniature Horse

Once the prized pets of royalty, tiny horses later worked in coal mines, first in England and then in the United States, even until the mid-1900s. Today they are immensely popular for showing, pleasure driving, and breeding.

HEIGHT: 34" and under

DESCRIPTION: Elegant, scaled-down version of a full-sized horse, often resembling a miniature Arabian. All colors that are found in full-sized horses both solid and spotted; also some that appear only in Miniatures, such as bay silver dapple.

SPECIAL QUALITIES: Diminutive animals of strength and athleticism with the proportions of full-sized horses rather than ponies

BEST SUITED FOR: Showing, driving, and as companion animals

PLACE OF ORIGIN

Developed in the United States, but the original stock probably came from England

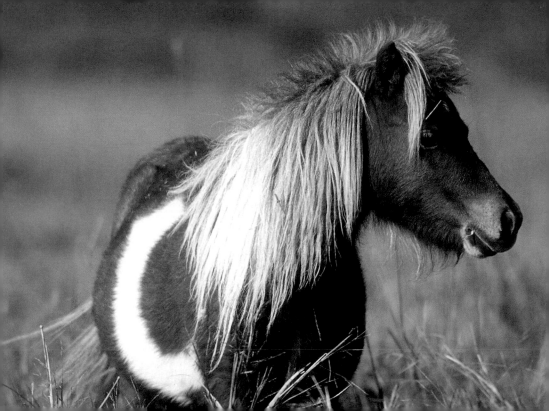

RARE

PONY

LIGHT HORSE

HEAVY HORSE

COLOR

gaited

112

Missouri Fox Trotter

Although best known for the fox trot, their intermediate-speed gait, these horses are versatile and athletic. They make excellent ranch horses but also ideal children's mounts, because they are gentle as well as comfortable.

HEIGHT: 14–16 hands

DESCRIPTION: Well-proportioned head with straight profile; pronounced withers, short back, and high tail set. All solid colors and pinto; often palomino or champagne colored; white facial and lower-leg markings common.

SPECIAL QUALITIES: A gaited breed known for its rhythmic diagonal gait called the "fox trot"

BEST SUITED FOR: Ranch work, trail riding, forest service work, handicapped riding programs, team penning, and showing

PLACE OF ORIGIN

Ozark Mountains of Missouri

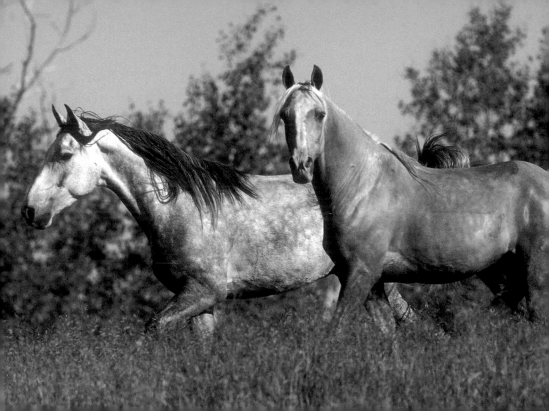

PONY

LIGHT
HORSE

HEAVY
HORSE

COLOR

Morab

This stunningly beautiful breed, a cross between the Morgan and the Arab, descends from the great Kentucky horse Golddust of the mid-19th century. Morabs are easy to train, late maturing, and long-lived.

HEIGHT: 14.3–15.3 hands

DESCRIPTION: Powerful and muscular; refined head with slightly concave profile; heavy yet refined neck; level croup with high tail set. Brown, bay, black, buckskin, gray, palomino, and dun.

SPECIAL QUALITIES: Steady disposition, strength, sensitivity, excellent free gaits

BEST SUITED FOR: Family and pleasure horses, trail riding, driving, jumping, and showing

PLACE OF ORIGIN

Extends from New England, to Kentucky, to Texas, to California

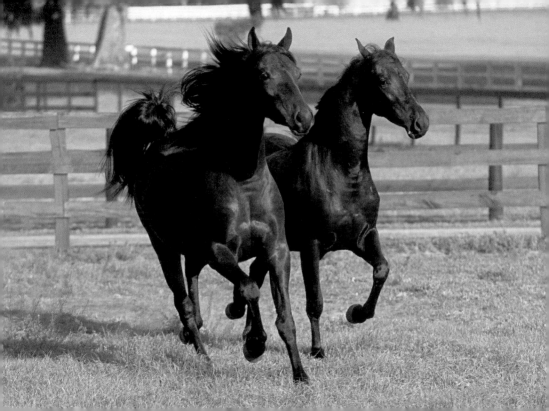

Morgan

Justin Morgan, a Vermont music teacher, owned an undersized bay stallion named Figure in 1792. The horse's legendary heart and excellent gaits became qualities of his descendants, but the breed took on the name of his owner.

PONY

LIGHT HORSE

HEAVY HORSE

COLOR

HEIGHT: 14.1–15.2 hands, may reach 16

DESCRIPTION: Arched neck; sloping shoulders and prominent withers; ribs well sprung and angled toward rear; exceptional depth of chest. Typically bay, black, brown, or chestnut; less commonly gray, palomino, cream, dun, and buckskin.

SPECIAL QUALITIES: Exceptional strength, staying power, soundness, and versatility

BEST SUITED FOR: All-around athletes; compete successfully in almost every discipline, from dressage and jumping to Western pleasure and cutting

PLACE OF ORIGIN

Vermont

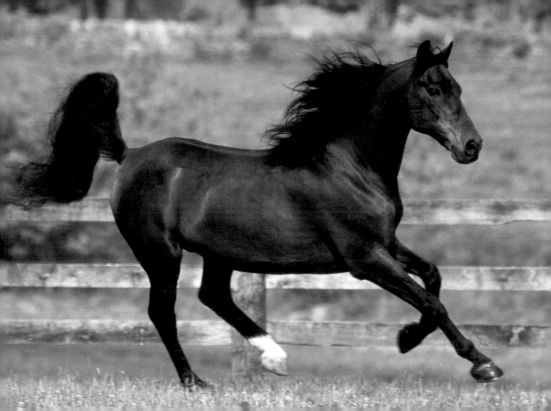

Moyle

Mormon settlers developed this breed in the mid-1800s. Used for long-distance riding, ranch work and, briefly, in the "Mormon pony express" for fast mail delivery, Moyles have incredible endurance and freedom of movement.

HEIGHT: 14.3–15.2

DESCRIPTION: Little bony knob over each eye, called a frontal boss, on some individuals; deep chest; forelegs placed far forward on body; long muscles; unusual length of body; dense coat.

SPECIAL QUALITIES: Tremendous endurance

BEST SUITED FOR: Endurance, trail riding

PLACE OF ORIGIN

Idaho

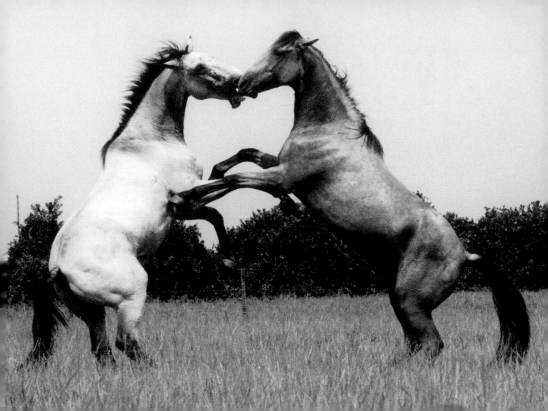

Mules and Hinnies

Mules and hinnies are versatile, strong, hardy, intelligent animals. A mule is the offspring of a male donkey or ass (a jack) and a female horse (a mare); a hinny, of a female donkey (a jenny) and a male horse (a stallion).

HEIGHT: Any size from Miniatures, 36" (9 hands), to draft, 17 hands or more

DESCRIPTION: Combines traits of horses and donkeys. The type of mule depends on the breeds of both parents.

SPECIAL QUALITIES: Extreme strength, tremendous ability to tolerate work, intelligence, heat tolerance, surefootedness, good night vision, strong sense of self preservation

BEST SUITED FOR: Farm work, driving, pulling, pleasure riding, packing, and racing

PLACE OF ORIGIN

The Middle East

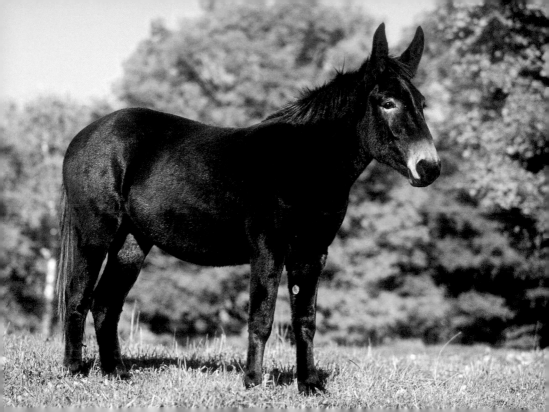

Mustang

*The most American of horses, this tough, enduring breed reflects the history and influences of the many peoples that came west or confronted the westward expansion. The name is from the Latin word **mixta**, meaning mixed breed.*

HEIGHT: 13.2–15 hands, average about 14.2

DESCRIPTION: Wiry and tough; often with Spanish traits such as convex profile, arched neck, narrow chest, short back, low tail set. All colors, reflecting the genetic contribution of many breeds.

SPECIAL QUALITIES: Toughness, cleverness, adaptability

BEST SUITED FOR: Trail riding, endurance riding, ranch work, contesting

PLACE OF ORIGIN

North America, particularly the Great Plains

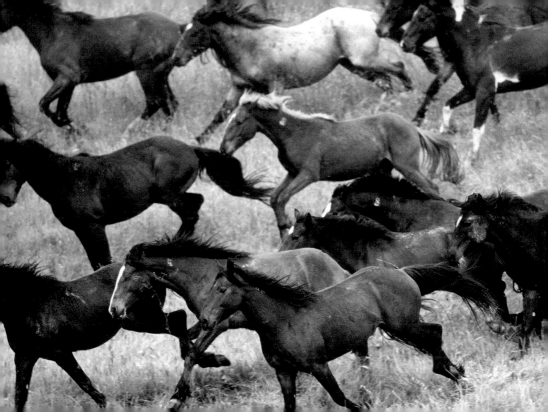

National Show Horse

This relatively new breed combines the best qualities of the Arabian and the American Saddlebred. Brilliance of motion comes from the Saddlebred side of the family, while refinement and beauty are added by the Arabian.

HEIGHT: Not specified by breed standard

DESCRIPTION: Small, refined head, straight or slightly concave profile; very long, upright, high-set neck; pronounced withers; short back with level topline; flowing, high-set tail. All solid colors and pintos.

SPECIAL QUALITIES: Beauty, presence, brilliance, and stamina

BEST SUITED FOR: Showing under saddle and in harness

PLACE OF ORIGIN

Arizona

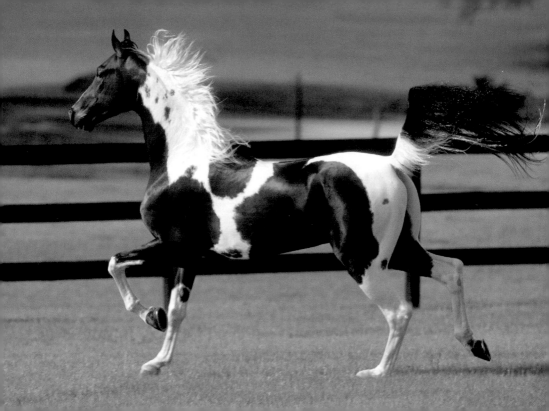

PONY

LIGHT
HORSE

HEAVY
HORSE

COLOR

Newfoundland Pony

With many breeds in its lineage, including the Connemara, the Dartmoor, the Exmoor, and the Fell, the Newfoundland is a versatile family mount. Its docile temperament and dense winter coat make it ideal for pulling sleighs.

HEIGHT: 11–14.2 hands

DESCRIPTION: Small head with large eyes and small ears with profuse hair; stocky body with strong neck and short back; sloping croup with low tail set; thick dense winter coat. Usually black, bay, and brown; also roan, chestnut, gray, and dun; color often changes in winter.

SPECIAL QUALITIES: A hardy, stocky pony whose extremely dense winter coat is often a strikingly different color than the summer coat

BEST SUITED FOR: Family pleasure, beginning riders, and driving

PLACE OF ORIGIN

Newfoundland, Canada, with genetic contributions from England, Ireland, and Scotland

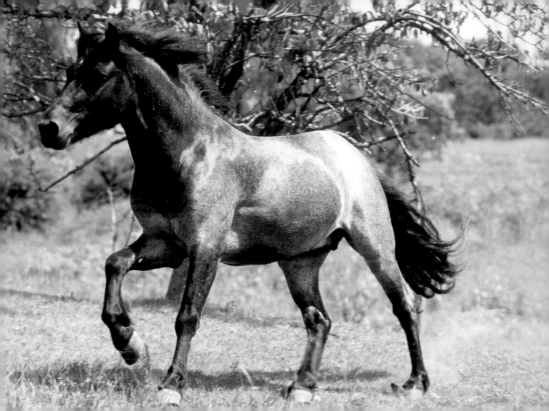

PONY

LIGHT
HORSE

HEAVY
HORSE

COLOR

Nokota

Descended from Sitting Bull's horses, this breed resembles the northern Plains Indian horse of the 19th century. Nokotas' athleticism and staying power have earned them fame in endurance trials.

HEIGHT: Traditional type, 14–14.3 hands; Ranch type, 14.2–17 hands

DESCRIPTION: Traditional type is small with Spanish traits; Ranch-type resembles early Quarter Horses, with Thoroughbred and Percheron influence. Frequently blue roan; also black and gray; less commonly, red roan and bay; blue eyes and a variety of pinto patterns sometimes seen.

SPECIAL QUALITIES: Tough, intelligent, sound horses of Spanish ancestry

BEST SUITED FOR: Pleasure and trail riding, endurance racing, ranch work, dressage, and jumping

PLACE OF ORIGIN

North Dakota

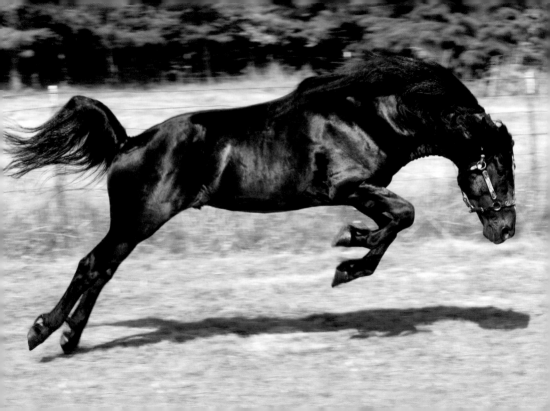

PONY

LIGHT
HORSE

HEAVY
HORSE

COLOR

North American Spotted Draft Horse

Although spotted draft horses have appeared in art for centuries, North American owners are currently developing this as a true breed. At present, these rare, beautiful horses often have Percheron and other draft ancestry.

HEIGHT: 15–17 hands

DESCRIPTION: Intelligent head with active ears and arched neck; upright shoulders; short, muscled forearms and thighs; deep heart girth and flank; short back; long hindquarters with level croup. Always pinto, most often black and white, sorrel and white, or bay and white.

SPECIAL QUALITIES: Splashy coloring on draft horse frame

BEST SUITED FOR: An all-around draft and carriage horse

PLACE OF ORIGIN

Midwestern United States, particularly Iowa

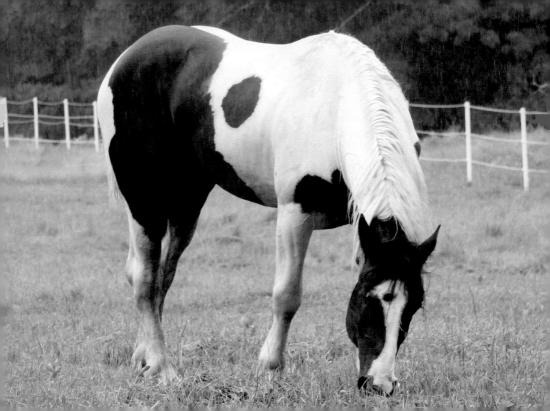

PONY

LIGHT
HORSE

HEAVY
HORSE

COLOR

Norwegian Fjord

Primitive wild horses migrated into Norway at least 4,000 years ago. The Vikings bred them as war mounts and took them wherever they went. The Fjord thus contributed its surefootedness and gentleness to many other breeds.

HEIGHT: 13.2–14.2 hands

DESCRIPTION: Concave profile; small ears; short, muscled neck and laid-back shoulders; compact, deep body; sloping croup; sturdy, short legs; light feathering. Always dun, with a dorsal stripe and zebra leg markings; coarse, upstanding mane with distinctive inner stripe.

SPECIAL QUALITIES: Good disposition, surefootedness, extremely comfortable gaits, and excellent endurance

BEST SUITED FOR: Riding, driving, packing, farm work; excellent children's mounts and all-around family horses; successful at the lower levels of dressage, jumping, and eventing

PLACE OF ORIGIN

Norway

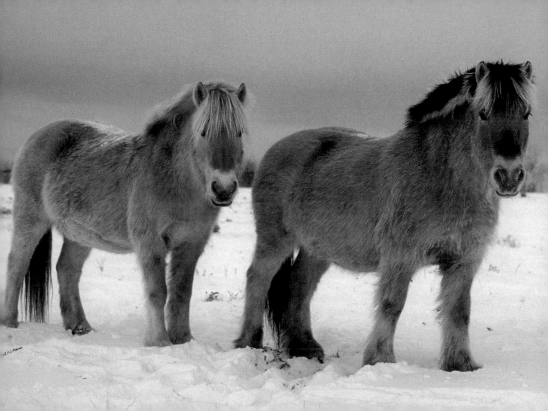

Oldenburg

For centuries this breed was a top-quality carriage and coach horse, valued in the military, agriculture, and mail service. After World War II it was developed into an outstanding sport horse.

HEIGHT: 16.2–17.2 hands

DESCRIPTION: Straight or convex profile; muscular but elegant neck, pronounced withers, and deep chest; fairly flat croup. Usually bay, brown, black, or gray; rarely, chestnut; may have white on face and lower legs.

SPECIAL QUALITIES: Power combined with a kind disposition, good movement, and an air of nobility with spirited, ground-covering movement

BEST SUITED FOR: Dressage, jumping, and combined driving

PLACE OF ORIGIN

Germany

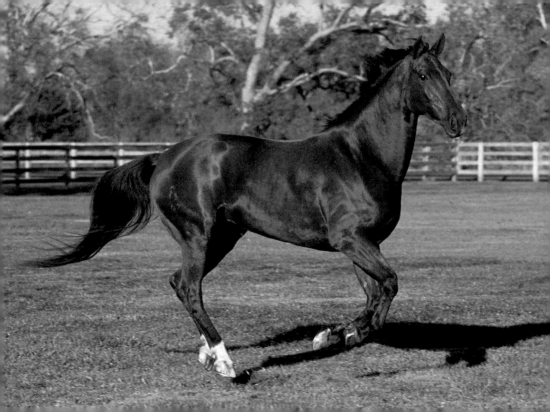

PONY

LIGHT
HORSE

HEAVY
HORSE

COLOR

Palomino

Beautiful golden horses with white manes and tails occur in many breeds around the world and have appeared in myths and art for millennia. In Columbus's time the queen of Spain loved these horses, called Isabellas.

COAT COLOR: Clear gold

MANE AND TAIL: White

SKIN: Dark

MARKINGS: Often white on legs and face

RELATED COLORS: Cremello

COLOR CLOSE-UP

A foal inherits the genes for coloring from both of its parents. It may also inherit a gene called the dilution gene. If the dilution gene is not present, the foal will be a sorrel. With one copy of the dilution gene the foal will be a palomino; with two copies it will be a pale color called cremello.

Paso Fino

The name Paso Fino means "fine step," describing the smooth, animated, four-beat lateral gait born into these traditional horses of Puerto Rico and Central and South America.

HEIGHT: 14–15 hands

DESCRIPTION: Small head with slightly convex profile; arched neck and oblique shoulders; long, full mane and tail. All colors and patterns except Appaloosa.

SPECIAL QUALITIES: Easy keepers with a unique, very short-strided, four-beat gait; known for their brio: lively, proud bearing

BEST SUITED FOR: Trail and pleasure riding, and showing

PLACE OF ORIGIN

Puerto Rico

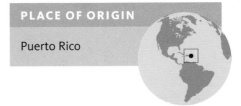

PONY

LIGHT
HORSE

HEAVY
HORSE

COLOR

Percheron

By the time of the Crusades, the Percheron was known for its soundness, substance, style, and beauty and was often selected as a warhorse. Though powerfully built, the breed is elegant and showy.

HEIGHT: 16–18 hands

DESCRIPTION: Medium-sized head, broad between eyes; wide, deep chest; straight, broad back with long, level croup and muscular quarters; large feet. Most often black or gray; occasionally bay, sorrel, or brown; minimal white markings.

SPECIAL QUALITIES: Elegant, predominantly gray or black draft breed without feathering on the lower legs

BEST SUITED FOR: Harness and carriage

PLACE OF ORIGIN

France

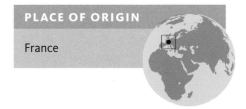

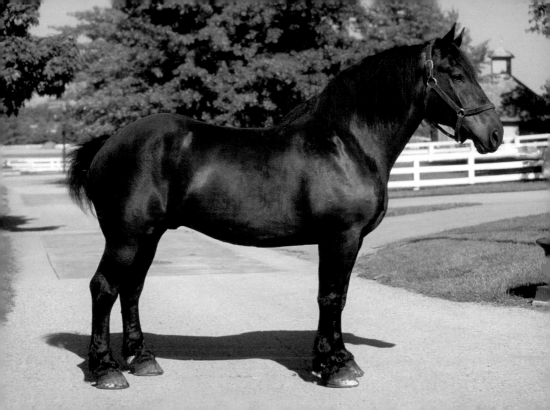

PONY

LIGHT HORSE

HEAVY HORSE

COLOR

gaited

142

Peruvian Paso

This spirited horse has an extremely soft gait, great sensitivity to the rider, a soft mouth, tremendous endurance, and the ability to adapt to various climatic conditions. Its exceptionally smooth four-beat gait is an inherited trait.

HEIGHT: 14–15 hands

DESCRIPTION: Medium-sized head with straight or slightly concave profile, small muzzle, inward-curving ears; muscular neck and wide chest; long, moderately sloped croup with low tail set; angled hocks. Bay, black, brown, buckskin, chestnut, dun, gray, grullo, palomino, and roan.

SPECIAL QUALITIES: A gaited horse known for elegance, endurance, brilliance, and spirit; easy to handle and ride

BEST SUITED FOR: Pleasure riding, trail riding, and showing

PLACE OF ORIGIN

Peru

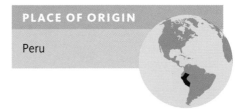

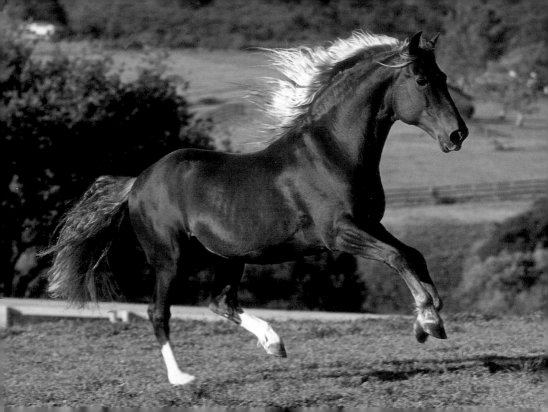

PONY

LIGHT
HORSE

HEAVY
HORSE

COLOR

Pinto

Pintos arrived in the New World with the Spanish, but these patterns have existed among horses for thousands of years. The British call pinto horses piebald (black and white) or skewbald (any other color and white).

COAT COLOR: Base coat white; spots black, brown, red, bay, roan, gray, buckskin, or palomino

MANE AND TAIL: Vary

SKIN: Varies

MARKINGS: Blazes, snips, stripes, stars; bald or bonnet face

COLOR CLOSE-UP

Pintos come in two common patterns. Tobiano horses have regular and distinct spots, white legs, and a multicolored tail, and their faces may have a star or blaze. Overos have irregular, splotchy markings, often a bald face, at least one colored leg, and rarely any white crossing the back. The horses pictured are tobianos.

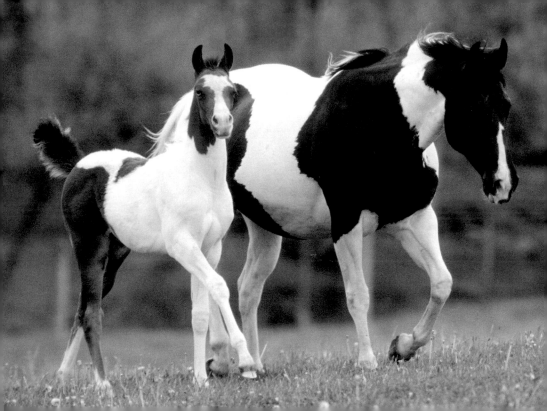

Pony of the Americas (POA)

Although breeders originally developed this breed as a Western or stock-type pony, its athletic ability, sound build, and gentle nature have carried it successfully into the worlds of endurance, eventing, show hunters, and driving.

HEIGHT: 11.2–14 hands

DESCRIPTION: Fine build with slightly dished profile and large eyes; slightly arched neck, prominent withers, and well-sloped shoulders; short back; long croup. Always Appaloosa, with mottled skin, white sclera, and striped hooves.

SPECIAL QUALITIES: Athletic; loudly colored with Appaloosa patterns

BEST SUITED FOR: All-around pleasure and competition mount for children and young adults

PLACE OF ORIGIN

Iowa

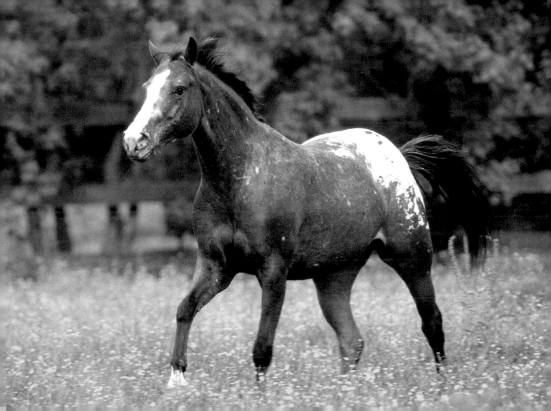

PONY

LIGHT
HORSE

HEAVY
HORSE

COLOR

gaited

148

Pryor Mountain Mustang

These horses arrived in the rugged, isolated Pryor Mountains at least 200 years ago, perhaps escaped from Crow traders or the Lewis and Clark expedition. Their history is a mystery, but they exhibit pure Spanish traits.

HEIGHT: 13–15 hands, with an average of 14–14.2

DESCRIPTION: Flat or slightly convex profile; narrow, deep body; short back; long, full mane and tail; sloping croup with low tail set. Grulla, dun, roan, palomino, and black; often with dorsal stripes, shoulder crosses, and occasionally zebra leg-stripes.

SPECIAL QUALITIES: A gaited breed of Spanish Colonial type

BEST SUITED FOR: Trail, pleasure, and endurance riding; ranch work; good choice for riders with physical limitations or a bad back and bad knees

PLACE OF ORIGIN

Pryor Mountains, Montana-Wyoming border

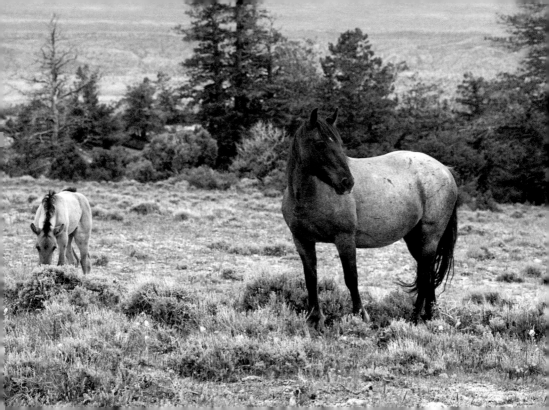

PONY

LIGHT
HORSE

HEAVY
HORSE

COLOR

gaited

150

Racking Horse

Racking horses have been popular, since before the Civil War, but a true breed was not established until recently. Owners value the horses' smooth, rapid gait (the rack), stamina, calm disposition, and good looks.

HEIGHT: 15.2 hands (average)

DESCRIPTION: Gracefully built with long, sloping shoulders and long, slightly arched neck; moderately sloped croup and medium tail set. Black, bay, sorrel, chestnut, brown, gray, palomino, or pinto (called "spotted" within the breed).

SPECIAL QUALITIES: A natural rack, stamina, willingness, and versatility

BEST SUITED FOR: Pleasure riding, trail riding, bird-dog field trials, and showing

PLACE OF ORIGIN

Southern
United States

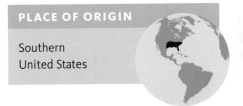

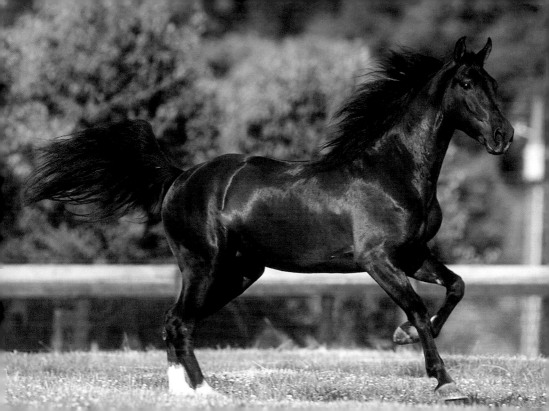

PONY

LIGHT
HORSE

HEAVY
HORSE

COLOR

gaited

152

Rocky Mountain Horse

This breed originated in the rugged, rocky hills of eastern Kentucky, not the Rocky Mountains of Colorado. These smooth-gaited horses were used to plow, work cattle, drive, ride, pack, and babysit the youngest riders.

HEIGHT: 14.2–16 hands

DESCRIPTION: Wide chest, well-sloped shoulders, and bold eyes; some show distinct Spanish features. Unusual, striking color combinations, with the body always a solid color, preferably chocolate, with white mane and tail.

SPECIAL QUALITIES: A naturally gaited horse known for gentleness and versatility; many are a striking chocolate color with white mane and tail

BEST SUITED FOR: Pleasure riding, trail and endurance riding, showing, ranch work; well suited to new riders, children, and riders with physical limitations

PLACE OF ORIGIN

Eastern Kentucky

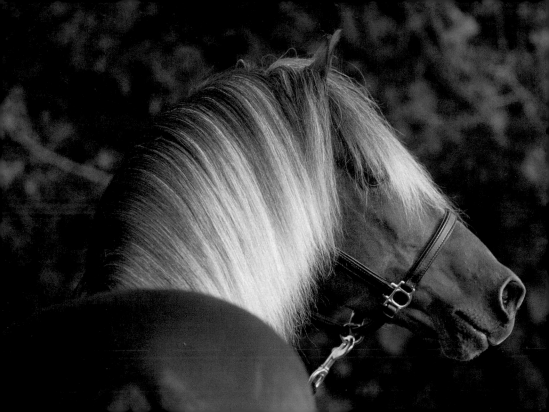

Sable Island Horse

The ancestors of this tough feral horse have survived in harsh conditions for centuries on a tiny, remote island off Nova Scotia. As with many island breeds, the scarcity of food limits the size of the horses.

HEIGHT: 13–14 hands

DESCRIPTION: Thick-bodied, stocky, and short. Recognizable Spanish traits include arched neck, sloping croup, and low tail set. Most commonly bay or brown, often with mealy muzzles and dorsal stripes, sometimes with white facial or lower-leg markings.

SPECIAL QUALITIES: Adapted to life on Sable Island; natural amblers; recognizable Spanish traits

BEST SUITED FOR: Endurance, pleasure riding, and ranch work

PLACE OF ORIGIN

Nova Scotia

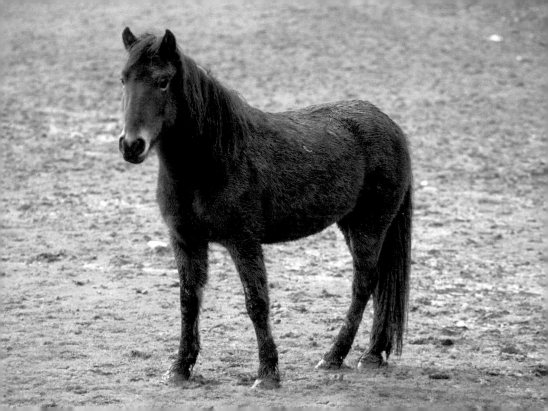

Selle Français

Internationally renowned for their jumping ability, these large, elegant, yet muscular horses are found on Olympic show-jumping teams from many countries. Many are unusually affectionate with an almost doglike desire to please.

HEIGHT: 16–17 hands

DESCRIPTION: Similar to a Thoroughbred, but with more bone and muscle; elegant yet robust; long neck, often large head; square-framed rather than rectangular. Most often chestnut or bay; occasionally red roan or gray.

SPECIAL QUALITIES: Exceptional temperament, jumping ability

BEST SUITED FOR: Show jumping, dressage, and eventing

PLACE OF ORIGIN

France

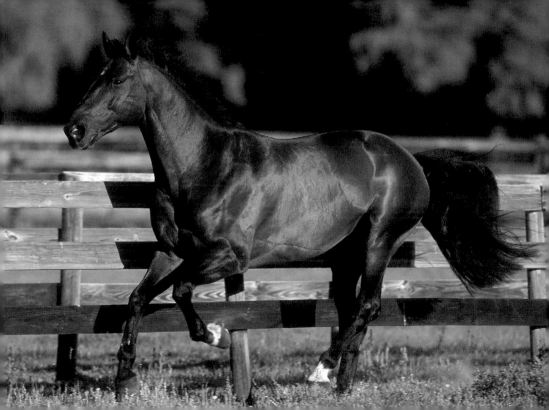

PONY

Shackleford Banker Pony

Wild horses have lived for centuries on the Outer Banks of North Carolina, where they have adapted well to a meager diet of salt grass. In winter they are rough and shaggy, but in summer they are always fat, sleek, and healthy.

HEIGHT: 13–14.3 hands

DESCRIPTION: Extremely hardy; many Spanish characteristics including a long, narrow head with flat or slightly convex profile, narrow but deep body, and low tail set. Buckskin, dun, bay, chestnut, black, and brown; pinto.

SPECIAL QUALITIES: The oldest documented horse population in North America and a historic treasure for both the state of North Carolina and the genetic history of North America's horses

BEST SUITED FOR: Pleasure riding and driving; good children's mounts

PLACE OF ORIGIN

Shackleford Island, Outer Banks of North Carolina; originally of Spanish stock

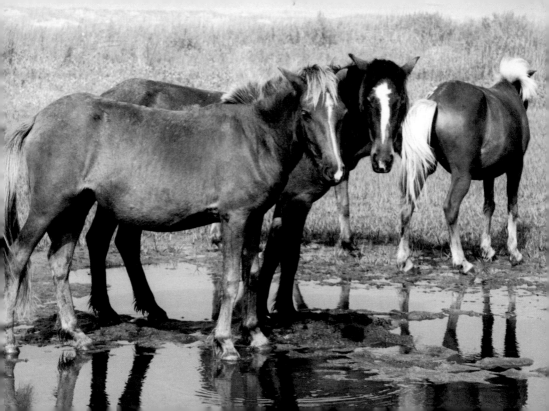

Shagya Arabian

Developed by Hungarian horsemen in the 18th and 19th centuries, Shagyas combine the best Arabian, Spanish, Thoroughbred, and Lipizzan blood. Statues still stand in Hungary, commemorating their courage in battle.

HEIGHT: 15–16 hands

DESCRIPTION: Similar to Arabians, but with more bone and substance; broad chest, close-coupled back, well-sloped shoulders and prominent withers. Most often gray, but come in all Arabian colors.

SPECIAL QUALITIES: A rare breed known for exceptional athleticism, endurance, courage, and an affectionate nature

BEST SUITED FOR: Jumping, dressage, endurance, eventing, and driving

PLACE OF ORIGIN

Hungary

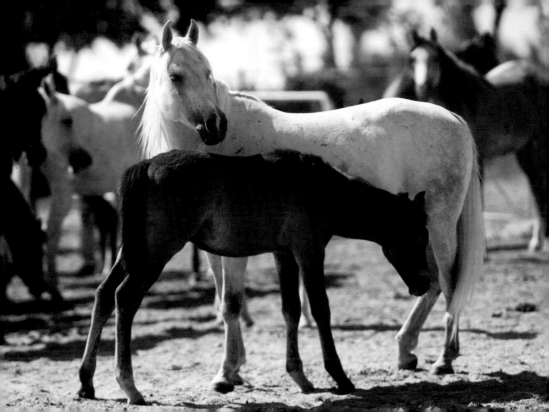

Shetland Pony

Hailing from the Shetland Islands off the north coast of Scotland, these hardy ponies are excellent mounts for children and fine family pets. They are good movers, nice jumpers, and first-rate, fun driving ponies for the entire family.

HEIGHT: Maximum in the United States, 11.5 hands; in Canada, 11 hands

DESCRIPTION: Short, clean-cut head with fine muzzle and brilliant eyes; well-balanced, strong sturdy body; full mane and tail; high tail set. All colors except Appaloosa.

SPECIAL QUALITIES: A small, sound, versatile breed of great hardiness

BEST SUITED FOR: Driving; traditional child's mount

PLACE OF ORIGIN

Shetland Islands, Great Britain, with probable ancestral roots in Scandinavia

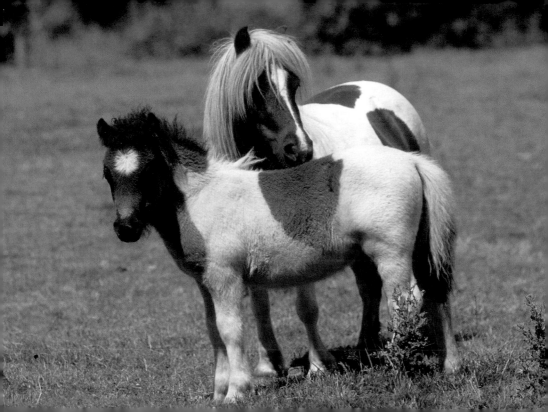

PONY

LIGHT
HORSE

HEAVY
HORSE

COLOR

Shire

The tallest of draft breeds, the Shire descends from the heavy horse used by the armies of King Henry II (1154–1189). Its lush feathering was developed to protect its legs from the wet, muddy conditions of the English countryside.

HEIGHT: 16.2–19 hands

DESCRIPTION: Long, lean head with broad forehead and slightly roman nose; long, arched, upright neck, deep sloping shoulders, and broad chest; deep girth, short back, and sloping croup; large feet. Black, brown, bay, gray, and chestnut; some white facial and leg markings.

SPECIAL QUALITIES: Tallest of the draft breeds and heaviest after the Brabant; heavy feathering on the legs

BEST SUITED FOR: Farm work, logging, and pulling carriages or wagons

PLACE OF ORIGIN

England

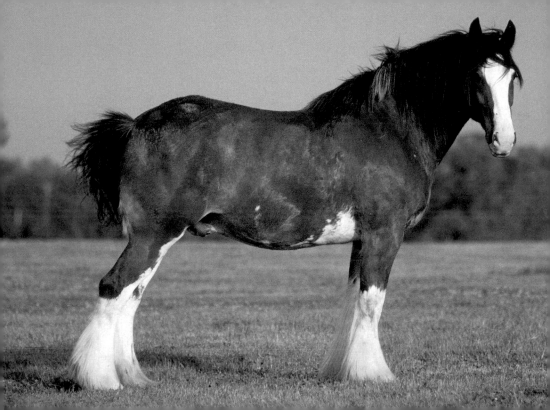

PONY

LIGHT
HORSE

HEAVY
HORSE

COLOR

gaited

166

Single-footing Horse

The single-foot is an intermediate four-beat gait with even timing, which can be performed at speeds up to more than 20 mph (28 kph). This breed specializes in this comfortable gait and has a tractable, willing disposition.

HEIGHT: 14.3–15.2 hands

DESCRIPTION: Similar to a Morgan but with a slightly more refined neck and a natural, well-balanced, single-foot gait. All colors.

SPECIAL QUALITIES: A gaited horse with good stock horse conformation, "cow sense," and a natural, strong, solid single-footing gait; also known for its pleasant, willing character

BEST SUITED FOR: Trail riding, endurance, and ranch work

PLACE OF ORIGIN

United States, earliest origin probably in the Southeast, but breed organization efforts came from the West

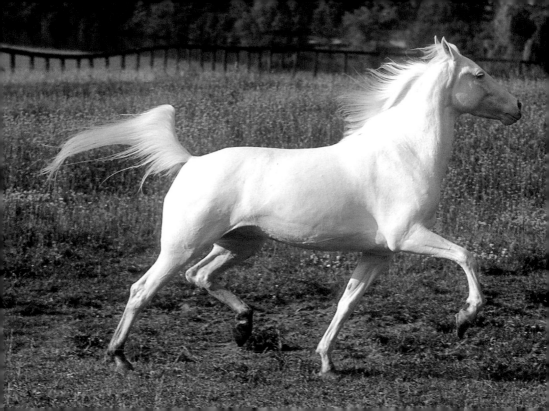

RARE

PONY

LIGHT
HORSE

HEAVY
HORSE

COLOR

Spanish Barb

During the Middle Ages the hot-blooded, desert-bred horses of North Africa were crossed with heavy Spanish warhorses to create this breed, one of the most successful horse types in history, a blend of elegance, agility, and durability.

HEIGHT: 13.3–14.3 hands

DESCRIPTION: Lean, refined Spanish head with straight or slightly convex profile; well-angled shoulders and short back; full mane and tail; low tail set. All colors.

SPECIAL QUALITIES: A critically rare breed of medium-sized, solid, well-built horses that exhibit Spanish traits

BEST SUITED FOR: Ranch and cattle work, all Western sports, and trail and endurance riding

PLACE OF ORIGIN

Spain

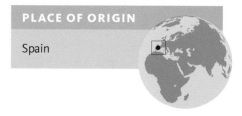

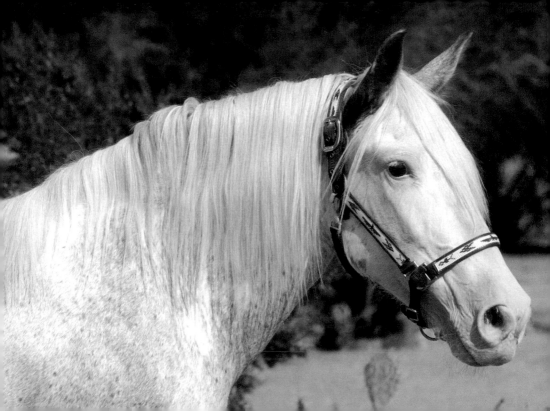

Spanish Colonial/ Spanish Mustang

These direct descendants of the first New World Spanish horses are closer in type to the horses of the Golden Age of Spain than any other breed, even those remaining in Europe. They are tough, quick, willing, and comfortable.

HEIGHT: 13–14.2 hands

DESCRIPTION: Classic Spanish-type head with broad, straight forehead and tapered, convex nose; narrow, angled deep chest with long, angled shoulder and prominent withers; short back and sloping croup with low tail set. Many solid colors and a range of pinto patterns.

SPECIAL QUALITIES: Natural herding ability, endurance

BEST SUITED FOR: Ranching, trail riding, endurance, and pleasure riding

PLACE OF ORIGIN

Original genetic contribution from Spain

PONY

LIGHT
HORSE

HEAVY
HORSE

COLOR

gaited

Spanish Jennet

The ancient Jennet, a small, smooth-gaited, often colorful ambler, is extinct, but its genes survive in breeds such as the Paso Fino and Peruvian Paso. The modern Jennet relies on these breeds' genetics for gait and type.

HEIGHT: 13.2–15.2 hands

DESCRIPTION: Aristocratic head with flat or slightly convex profile; arched, high-set neck, deep chest, and defined withers; thick, full mane and tail; medium to low tail set. All base body colors except gray; pinto and leopard Appaloosa common.

SPECIAL QUALITIES: A breed of gaited, colored horses of Spanish type

BEST SUITED FOR: Pleasure riding, trail riding, ranch work, showing; smooth gaits make them a good choice for riders with physical limitations

PLACE OF ORIGIN

Spain

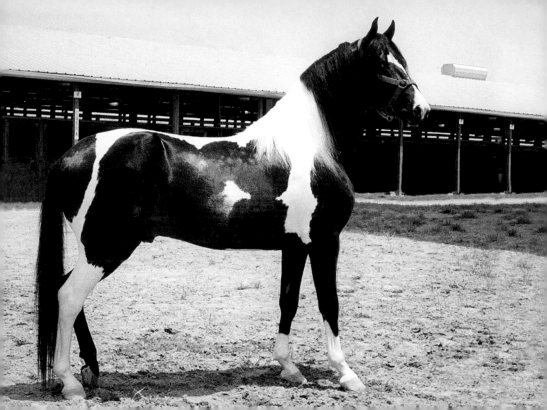

Standardbred

This all-American harness-racing breed includes both trotters and pacers. After their race careers are over, their calm dispositions and willingness to work make them excellent pleasure riding and driving animals.

HEIGHT: 15–15.3 hands

DESCRIPTION: Straight or slightly convex profile; long ears; short, straight neck; long, muscular body; sloping quarters; thick mane and tail. Usually bay, brown, or black, less commonly chestnut, roan, or gray, with minimal white on face or lower legs.

SPECIAL QUALITIES: Very fast trot or pace; excellent endurance and ability to tolerate work; calm disposition

BEST SUITED FOR: Harness racing, pleasure driving, and pleasure riding; and the breed of choice as Amish buggy horses.

PLACE OF ORIGIN

Eastern North America

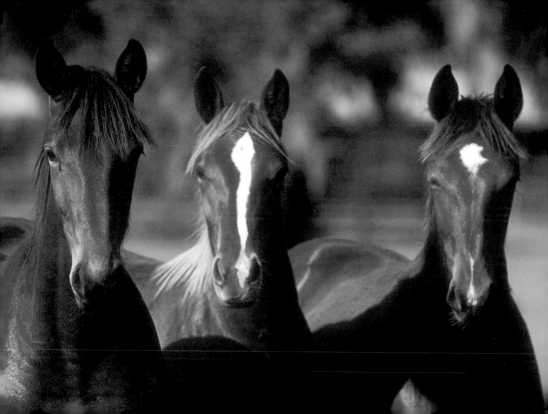

PONY

LIGHT
HORSE

HEAVY
HORSE

COLOR

Suffolk Punch

With its bright chestnut coloring and short legs, the sturdy Suffolk Punch — the oldest draft breed in England — has changed very little over the centuries. Exceptionally long-lived, it is an ideal breed for horse-powered farms.

HEIGHT: 16.1–17 hands

DESCRIPTION: Large, symmetrical body; intelligent head on powerful arched neck; upright shoulders; deep heart girth and flank; short back, smooth quarters, level croup, and high-set tail; close-set, proportionally short legs. Always some shade of chestnut, sometimes with a small star or snip; occasionally white on fetlocks.

SPECIAL QUALITIES: Extremely rare; in England fewer than 100 horses; world population of fewer than 3,500

BEST SUITED FOR: Farming and logging

PLACE OF ORIGIN

Suffolk, England

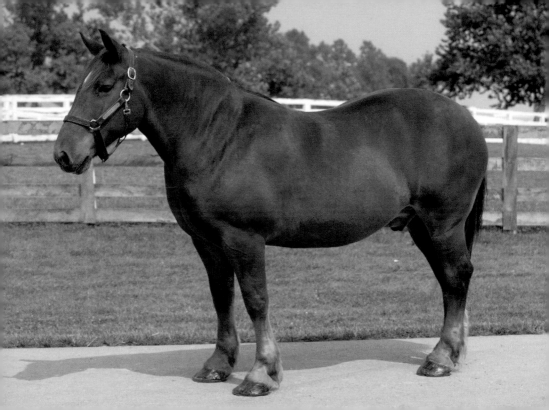

RARE

PONY

LIGHT
HORSE

HEAVY
HORSE

COLOR

Sulphur Horse

The ancestors of these feral horses, with their strong heritage of Spanish traits, probably escaped several hundred years ago from traders along the Old Spanish Trail through Utah. The government now protects them.

HEIGHT: 13–15.1 hands

DESCRIPTION: Narrow, clean-cut head with almond-shaped eyes; long, slanting shoulders; prominent withers; slightly sloping croup with medium to low tail set. All solid colors; never pinto; may have dorsal stripe.

SPECIAL QUALITIES: Horses of Spanish Colonial type, many of which are dun or buckskin

BEST SUITED FOR: Trail and endurance riding, ranch work, pleasure riding, and all Western sports

PLACE OF ORIGIN

Southwestern Utah

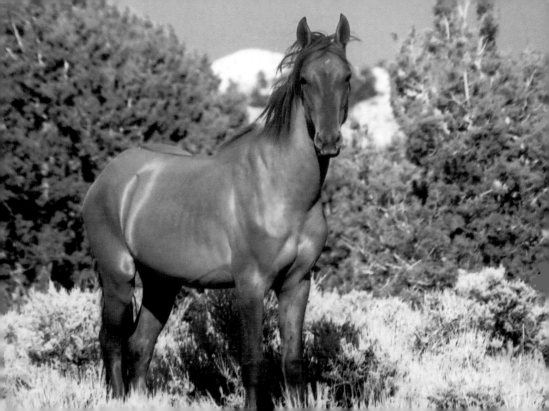

Tennessee Walking Horse

Although many people today know Walkers only as show horses, the breed originated as a highly functional, hard-working horse that could perform every job on a farm, from pulling plows to racing to carrying the children to school.

HEIGHT: 14.3–17 hands

DESCRIPTION: Refined yet solid; long neck and long, sloping shoulders, short back and long hips. All solid colors and roans as well as pintos.

SPECIAL QUALITIES: Naturally smooth-gaited, known for nodding their head at the running walk

BEST SUITED FOR: Trail riding, pleasure riding, and showing

PLACE OF ORIGIN

Tennessee

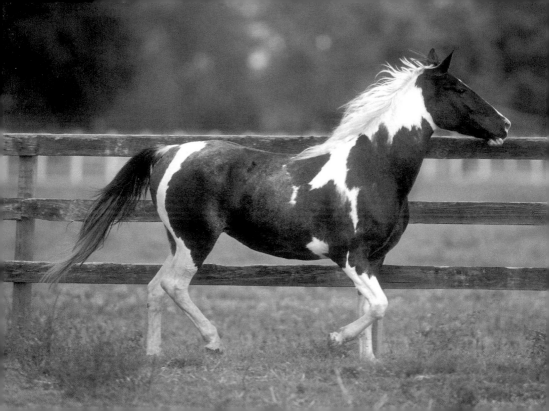

PONY

LIGHT
HORSE

HEAVY
HORSE

COLOR

Thoroughbred

No other breed has the combination of speed, endurance, and heart found in Thoroughbreds. Each pedigree traces back to one of three 17th-century stallions: the Godolphin Arabian, the Byerly Turk, or the Darley Arabian.

HEIGHT: 15–17 hands

DESCRIPTION: Small, elegant head with straight profile and large eyes; very long neck and well-sloped, muscular shoulders; prominent withers and long back; sloping croup with high tail set; fine, silky coat. Usually bay, black, chestnut, or gray; very rarely, pinto.

SPECIAL QUALITIES: Speed, grace, bravery, and willingness

BEST SUITED FOR: Racing, polo, foxhunting, jumping, eventing, and showing

PLACE OF ORIGIN

England

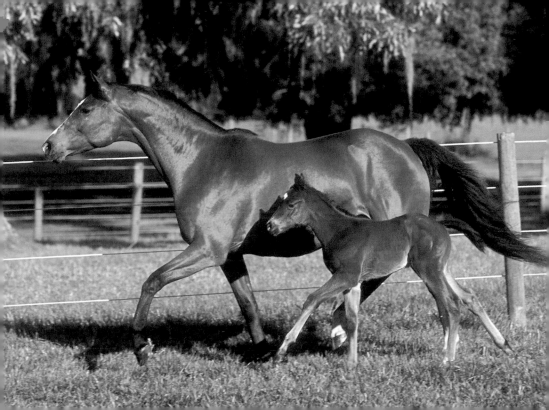

RARE

PONY

LIGHT HORSE

HEAVY HORSE

COLOR

gaited

184

Tiger Horse

The name of this colorful breed comes from the Spanish word tigre *(a cat with a patterned coat). Developed by the Ni Mee Poo (Nez Percé) of the Pacific Northwest, the Tiger's gaits include the comfortable "Indian shuffle."*

HEIGHT: 13–16 hands, with 14–15.2 hands being most typical and desirable

DESCRIPTION: Lean head with straight or slightly convex profile; high-set neck, well-defined withers, sloping croup, and low-set tail. Appaloosa patterns include leopard, blanket (shown), roan, and snowflake.

SPECIAL QUALITIES: A rare gaited breed with excellent learning capacity and great heart.

BEST SUITED FOR: Trail riding, ranch work, pleasure riding; good horses for riders with physical limitations

PLACE OF ORIGIN

Northwestern United States

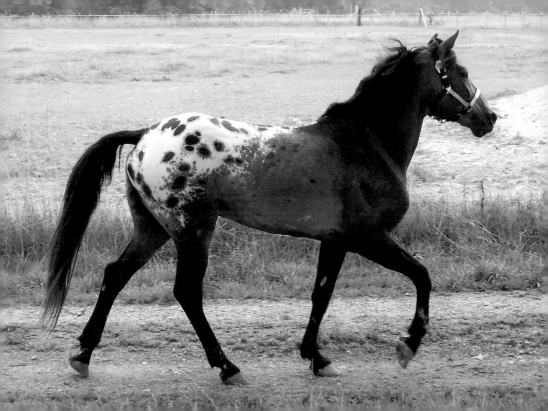

Trakehner

The picture of elegant power, this breed goes back to the 1790s, excelling in Olympic competition since the 1920s. Most of the horses were lost during World War II, but extraordinary efforts since then have saved the breed.

PONY

LIGHT HORSE

HEAVY HORSE

COLOR

HEIGHT: 16–17 hands

DESCRIPTION: Rectangular in shape and lighter-boned than many warmbloods; distinctive head, sometimes with slightly dished profile; long neck and prominent withers; high tail set. Most often chestnut, bay, brown, black, and gray; occasionally pinto, which is not encouraged.

SPECIAL QUALITIES: Regal presence, ground-covering gaits, athleticism

BEST SUITED FOR: Show jumping, dressage, and eventing

PLACE OF ORIGIN

East Prussia
(Lithuania)

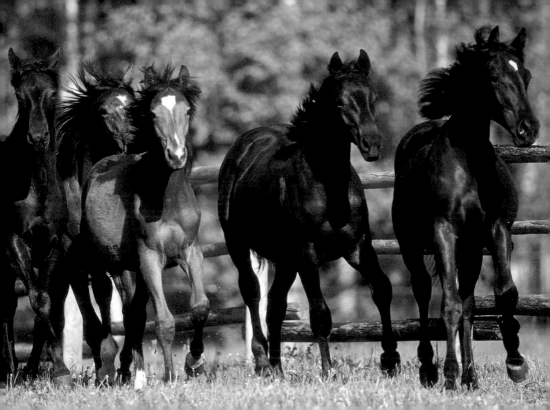

PONY

LIGHT
HORSE

HEAVY
HORSE

COLOR

Welara Pony

This breed was developed by crossing one of the most beautiful horse breeds, the Arabian, with one of the most beautiful pony breeds, the Welsh. The Welara is elegant, refined, hardy, spirited, and athletic.

HEIGHT: 11.2–15 hands

DESCRIPTION: Small, clean-cut head with tapering muzzle and slightly concave profile; long, high-set neck and well laid-back shoulders; long, horizontal croup with high tail carriage. All colors and patterns except Appaloosa.

SPECIAL QUALITIES: A strikingly beautiful, sound, athletic pony

BEST SUITED FOR: Showing, especially in fine harness, pleasure driving, hunter pony, Western and English pleasure, and at halter; trail competition and pleasure riding and driving

PLACE OF ORIGIN

England and the
United States

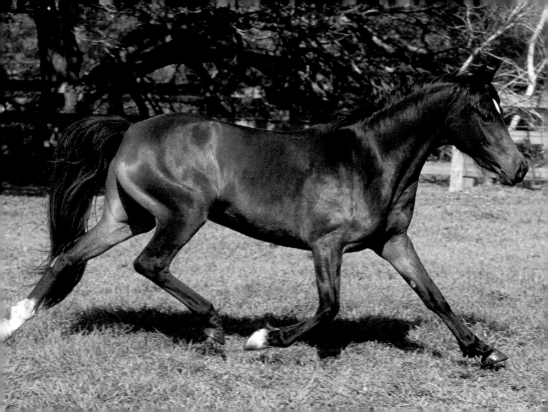

PONY

LIGHT
HORSE

HEAVY
HORSE

COLOR

Welsh Ponies and Cobs

The sturdy yet elegant Welsh Pony has a distinguished history dating back to the time of the Romans. Its ancestors were probably ancient Celtic ponies, with Arabian blood mixed in. A Cob has a heavier build.

HEIGHT: 11–13.2 hands for ponies; 13.2 hands (with no upper limit) for Cobs

DESCRIPTION: Several types with different lineage and body type. For all types, small head with pointed ears and concave profile; well-defined withers; high-set tail. All solid colors, especially gray, brown, and chestnut.

SPECIAL QUALITIES: Beautiful animals noted for soundness, excellence of movement, and jumping talent

BEST SUITED FOR: Jumping, driving, and children's pleasure riding

PLACE OF ORIGIN

Wales

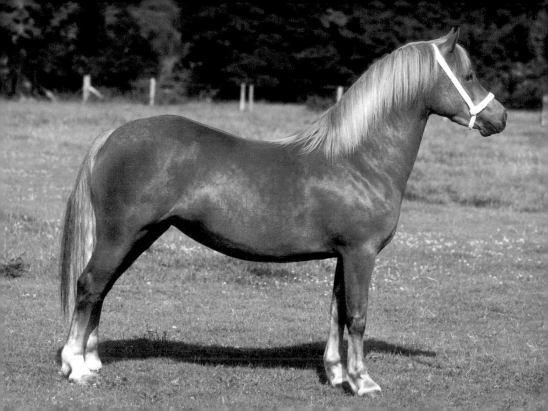

PONY

LIGHT
HORSE

HEAVY
HORSE

COLOR

Westfalen/Westphalian

Once a Prussian farm horse, the Westfalen is now one of the world's most popular warmblood breeds, excelling in sport. It is valued for its spectacular movement and willingness to accept direction from the rider.

HEIGHT: 16–17 hands

DESCRIPTION: Tall; attractive head with straight or slightly dished profile; long neck and powerful, sloping shoulders; deep, muscular body; flat croup. All colors.

SPECIAL QUALITIES: Tremendous and powerful gaits; athletic ability

BEST SUITED FOR: Show jumping, dressage, field and show hunters; all sport horse activities

PLACE OF ORIGIN

Germany

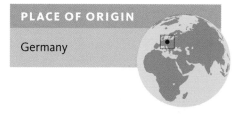

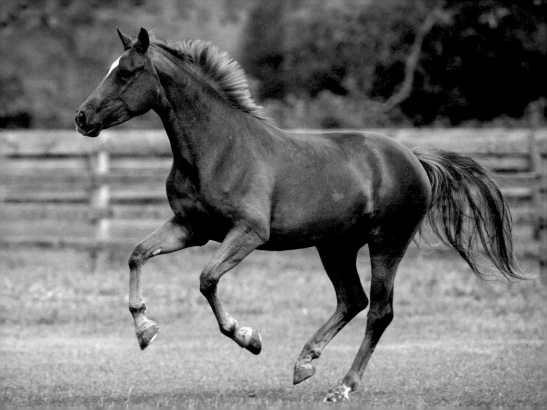

Wilbur-Cruce Mission Horse

These sturdy horses thrived for hundreds of years in the rugged backlands of Arizona. They are now considered a distinct population within the Spanish Barb registry.

HEIGHT: 14–15 hands

DESCRIPTION: Typical Spanish Barb characteristics, including straight or slightly convex profile, narrow but deep body, and sloped croup with low-set tail. Black, sorrel, chestnut, roan, grullo, dun, buckskin, or pinto.

SPECIAL QUALITIES: A strain of the critically endangered Spanish Barb; exhibits Spanish conformation, surefootedness, courage, and inborn "cow sense"

BEST SUITED FOR: Ranch work, trail and endurance riding, all Western sports

PLACE OF ORIGIN

Southern Arizona

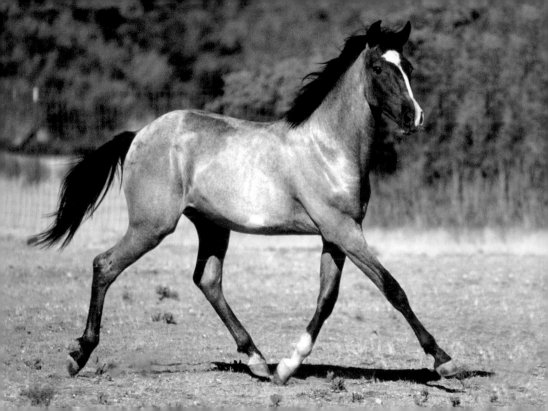

What Different Breeds Do Best

Although some breeds have exceptional talent at specific activities, individual horses may excel in almost any discipline. This list is only a generalized summary.

ALL-AROUND FAMILY HORSE
Haflinger
Kentucky Mountain Saddle
Morab
Newfoundland Pony
Norwegian Fjord

BEGINNING RIDERS, WORKING WITH
Lac La Croix Indian Pony
Newfoundland Pony

CHILD'S FIRST MOUNT
Caspian
Chincoteague Pony
Connemara Pony
Dales Pony
Dartmoor Pony
Exmoor Pony
Gotland Pony
Kerry Bog Pony
Newfoundland
Pony of the Americas
Shackleford Banker Pony
Shetland Pony

Welsh Ponies and Cobs

COMPANIONSHIP
Donkeys
Kerry Bog Pony
Miniature Horse

CUTTING
American Quarter Horse
Azteca
Galiceno
Morgan

DISABLED/LIMITED RIDERS, WORKING WITH
Exmoor Pony
Kerry Bog Pony
Lac La Croix Indian Pony
Mangalarga Marchador
Miniature Horse
Missouri Fox Trotter
Mountain Pleasure
Pryor Mountain Mustang
Rocky Mountain Horse
Spanish Jennet

Tennessee Walking Horse
Tiger Horse

DRAFTWORK
American Cream Draft
Belgian
Brabant
Clydesdale
Connemara Pony (light)
North American Spotted
 Draft Horse
Percheron
Shire

DRESSAGE
Akhal-Teke
Andalusian
Azteca
Canadian Sport Horse
Cleveland Bay
Connemara Pony
Dales Pony
Dutch Warmblood
Friesian
Gypsy Vanner

Haflinger
Hanoverian
Holstein
Hungarian Horse
Irish Draught
Lipizzan
Lusitano
Marwari
Morgan
Nokota
Norwegian Fjord
Oldenburg
Selle Français
Shagya Arabian
Trakehner
Westfalen/Westphalian

DRIVING, PLEASURE/COMBINED
American Cream Draft
American Walking Pony
Belgian
Canadian Horse
Canadian Sport Horse
Caspian

Chincoteague Pony
Cleveland Bay
Clydesdale
Connemara Pony
Dales Pony
Dartmoor Pony
Dutch Warmblood
Exmoor Pony
Fell Pony
Friesian
Gotland Pony
Gypsy Vanner
Hackney Horse
Hackney Pony
Haflinger
Hanoverian
Holsteiner
Hungarian Horse
Irish Draught
Kerry Bog
Lac La Croix Indian Pony
Lipizzan
Miniature Horse
Morab
Newfoundland Pony
North American Spotted
 Draft
Norwegian Fjord
Oldenburg
Percheron
Shackleford Banker Pony
Shagya Arabian
Shetland Pony

Shire
Standardbred
Welara Pony
Welsh Ponies and Cobs

ENDURANCE
Akhal-Teke
American Curly Horse
American Indian Horse
Arabian
Cerbat
Exmoor Pony
Florida Cracker
Galiceno
Icelandic Horse
Kiger Mustang
Mangalarga Marchador
Marwari
Morgan
Moyle
Mustang
Nokota
Pryor Mountain Mustang
Rocky Mountain Horse
Sable Island Horse
Shagya Arabian
Single-footing Horse
Spanish Barb
Spanish Colonial/Mustang
Sulphur Horse
Wilbur-Cruce Mission
 Horse

EVENTING
Canadian Sport Horse
Connemara Pony
Clydesdale
Connemara Pony (light)
Dales Pony
Fell Pony
Hackney Pony
Haflinger
Hungarian Horse
Irish Draught
North American Spotted
 Draft Horse
Norwegian Fjord
Selle Français
Shagya Arabian
Thoroughbred
Trakehner

FARM WORK
American Cream Draft
Belgian
Brabant
Haflinger
Kentucky Mountain Saddle
Mules and Hinnies
Norwegian Fjord
Percheron
Shire
Suffolk Punch
Tennessee Walking Horse

FIELD AND SHOW HUNTERS
Cleveland Bay
Hanoverian
Holsteiner
Oldenburg
Trakehner
Westfalen/Westphalian

FIELD TRIALS
McCurdy Plantation Horse
Racking Horse
Tennessee Walking Horse

FOREST SERVICE WORK
Missouri Fox Trotter
Mules

FOXHUNTING
Canadian Horse
Canadian Sport Horse
Chincoteague Pony
Connemara Pony
Dales Pony
Hungarian
Irish Draught
Selle Français
Thoroughbred
Welara Pony

GUARDING LIVESTOCK
Donkeys

What Different Breeds Do Best (continued)

HARNESS RACING
Standardbred

HITCH AND PULLING COMPETITION
American Cream Draft Horse
Belgian
Brabant
Clydesdale
Mules
North American Spotted Draft Horse
Percheron

JUMPING
American Walking Pony
Appaloosa
Canadian Horse
Canadian Sport Horse
Caspian
Connemara Pony
Dartmoor Pony
Dutch Warmblood
Fell Pony
Gotland Pony
Hackney Horse / Pony
Haflinger
Hanoverian
Holsteiner
Hungarian Horse
Irish Draught
Morab
Morgan
Mules
Nokota
Norwegian Fjord
Oldenburg
Selle Français
Shagya Arabian
Thoroughbred
Trakehner
Welsh Ponies and Cobs
Westfalen/Westphalian

LOGGING
American Cream Draft
Belgian
Brabant
Clydesdale
Mules
Percheron
Shire
Suffolk Punch

MOUNTED BULLFIGHTING
Andalusian
Azteca
Lusitano

PACKING
Donkeys
Haflinger
Icelandic
Mules and Hinnies
Norwegian Fjord

PARADE HITCHES
American Cream Draft
Belgian
Clydesdale
Percheron
Shire

PLEASURE RIDING
American Cream Draft
American Quarter Horse
American Saddlebred
American Walking Pony
Andalusian
Arabian
Azteca
Canadian Horse
Cerbat
Chincoteague Pony
Colorado Rangerbred
Friesian
Gypsy Vanner
Haflinger
Kiger Mustang
Lipizzan
Lusitano
Mangalarga Marchador
Marwari
McCurdy Plantation Horse
Morab
Morgan
Mules and Hinnies
Nokota
Norwegian Fjord
Paso Fino
Peruvian Paso
Pryor Mountain Mustang
Racking Horse
Rocky Mountain Horse
Sable Island Horse
Shackleford Banker Pony
Spanish Colonial/Mustang
Spanish Jennet
Standardbred
Sulphur Horse
Tennessee Walking Horse
Tiger Horse
Welara Pony

POLO
Azteca
Thoroughbred

RACING

American Quarter Horse
(short-distance)
Appaloosa (middle-distance)
Arabian (long-distance and
endurance)
Mules and Hinnies
Mustang (endurance)
Nokota (endurance)
Paint (short-distance)
Standardbred (harness)
Thoroughbred (sprints to
long-distance)

RANCH AND/OR CATTLE WORK

American Curly Horse
American Paint Horse
American Quarter Horse
American Quarter Pony
Andalusian
Appaloosa
Cerbat
Colorado Rangerbred
Florida Cracker
Kiger Mustang
Lusitano
Mangalarga Marchador
Missouri Fox Trotter
Morgan
Nokota
Pryor Mountain Mustang
Rocky Mountain Horse

Sable Island Horse
Single-footing Horse
Spanish Barb
Spanish Colonial/Mustang
Spanish Jennet
Sulphur Horse
Tiger Horse
Wilbur-Cruce Mission
Horse

REINING

American Paint Horse
American Quarter Horse
Appaloosa
Azteca
Galiceno

TEAM PENNING AND ROPING

American Paint Horse
American Quarter Horse
American Quarter Pony
Appaloosa
Azteca
Cerbat
Colorado Rangerbred
Florida Cracker
Missouri Fox Trotter
Kiger Mustang
Mustang
Spanish Barb
Sulphur Horse
Wilbur-Cruce Mission Horse

TRAIL RIDING

American Curly Horse
American Paint Horse
American Saddlebred
American Walking Pony
Appaloosa
Arabian
Cerbat
Chincoteague Pony
Colorado Rangerbred
Connemara Pony
Dales Pony
Fell Pony
Florida Cracker
Galiceno
Hackney Pony
Icelandic Horse
Kentucky Mountain Saddle
Kiger Mustang
Mangalarga Marchador
McCurdy Plantation Horse
Missouri Fox Trotter
Morab
Morgan
Moyle
Mustang
Nokota
Paso Fino
Peruvian Paso
Pryor Mountain Mustang
Racking Horse
Rocky Mountain Horse
Single-footing Horse

Spanish Barb
Spanish Colonial/Mustang
Spanish Jennet
Sulphur Horse
Tennessee Walking
Horse
Tiger Horse
Welara Pony
Wilbur-Cruce Mission
Horse

WESTERN COMPETITION, SPORT

American Paint Horse
American Quarter Horse
American Quarter Pony
Appaloosa
Cerbat
Colorado Rangerbred
Hackney Pony
Kiger Mustang
Mustang
Pony of the Americas
Spanish Barb
Sulphur Horse
Wilbur-Cruce Mission
Horse

Average Horse Height in Hands

Miniature Horse	7–9.2	Shackleford Banker Pony	13–14.3
Donkeys	9–16	Haflinger	13–15
Mules and Hinnies	9–17	Pryor Mountain Mustang	13–15
Kerry Bog Pony	10–11	Sulphur Horse	13–15.1
Caspian	10–12	American Indian Horse	13–16
Shetland Pony	10–11.5	Tiger Horse	13–16
Welsh Pony	11–13.2	Welsh Cob	13.2 and above
Newfoundland Pony	11–14.2	Fell Pony	13.2–14.2
Kentucky Mountain Saddle	11–15.2	American Walking Pony	13.2–14.2
Exmoor Pony	11.2–12.3	Cerbat	13.2–14.2
Pony of the Americas	11.2–14	Chincoteague	13.2–14.2
American Quarter Pony	11.2–14.2	Norwegian Fjord	13.2–15
Welara Pony	11.2–15	Florida Cracker	13.2–15
Dartmoor Pony	11.2–12.2	Mustang	13.2–15
Lac La Croix Indian Pony	12–13.2	Spanish Jennet	13.2–15.2
Gotland Pony	12–14	Spanish Barb	13.3–14.3
Galiceno	12–14.1	Dales	14–14.2
Hackney Pony	12.2–14.2	Kiger Mustang	14–15
Icelandic Horse	12.2–14.3	Paso Fino	14–15
Abaco Barb	13	Peruvian Paso	14–15
Sable Island Horse	13–14	Wilbur-Cruce Mission Horse	14–15
Connemara Pony	13–14.2	Gypsy Vanner	14–15.2
Spanish Colonial/Mustang	13–14.2	Arabian	14–15.3

Missouri Fox Trotter	14–16	American Saddlebred	15–17
Nokota	14–17	Friesian	15–17
Morgan	14.1–15.2	Thoroughbred	15–17
Marwari	14.2–15.2	North American Spotted Draft	15–17
Colorado Rangerbred	14.2–16	Racking Horse	15.2
Hackney Horse	14.2–16	Brabant	15.2–18.2
McCurdy Plantation Horse	14.2–16	Dutch Warmblood	15.2–17
Rocky Mountain Horse	14.2–15.2	Irish Draught	15.2–17
American Paint Horse	14.2–16.2	Hungarian Horse	15.3–17
Appaloosa	14.2–16.2	Canadian Sport Horse	16+
American Quarter Horse	14.2–17	Cleveland Bay	16–17
American Curly Horse	14.3–15.2	Holsteiner	16–17
Mangalarga Marchador	14.3–15.2	Selle Francais	16–17
Moyle	14.3–15.2	Trakehner	16–17
Single-footing Horse	14.3–15.2	Westfalen/Westphalian	16–17
Morab	14.3–15.3	Hanoverian	16–17.2
Canadian Horse	14.3–16.2	Belgian	16–18
Tennessee Walking Horse	14.3–17	Percheron	16–18
Lipizzan	15–15.3	Suffolk Punch	16.1–17
Standardbred	15–16.2	Oldenburg	16.2–17.2
Akhal-Teke	15–16	Clydesdale	16.2–18
Andalusian and Lusitano	15–16	Shire	16.2–19
Shagya Arabian	15–16	National Show Horse	height unspecified
Azteca	15–16.1		
American Cream Draft	15–16.3		

Breed Association Websites

Every effort was made to confirm the accuracy of these listings. Any correction or updates should be sent to Deb Burns, Editor, Storey Publishing, deb.burns@storey.com

Abaco Barb
www.arkwild.org

Akhal-Teke
www.akhal-teke.org

American Cream Draft
www.acdha.org

American Curly
www.abcregistry.org

American Indian Horse
www.indianhorse.com

American Paint Horse
www.apha.com

American Quarter Horse
www.aqha.com

American Saddlebred
www.asha.net

American Walking Pony
www.rowntreehorses.net

Andalusian/Lusitano
www.ialha.org

Appaloosa
www.appaloosa.com

Arabian
www.arabianhorses.org

Azteca
www.aztecana.com

Belgian
www.belgiancorp.com

Brabant
www.ruralheritage.com/brabant

Buckskin
www.ibha.net

Canadian Horse
www.lechevalcanadien.ca

Canadian Sport Horse
www.c-s-h-a.org

Caspian
www.caspian.org

Cerbat
Cerbats may be registered with the Spanish Mustang Registry
www.spanishmustang.org

Chickasaw Horse
704-592-7451

Chincoteague Pony
www.pony-chincoteague.com

Choctaw Horse
www.red-road-farm.com

Cleveland Bay
www.clevelandbay.com

Clydesdale
http://clydesusa.com

Colorado Rangerbred
www.coloradoranger.com

Connemara
www.acps.org
www.cpbs.ie

Dales
www.dalesponies.com
www.dalespony.org
www.dalesponyassoc.com

Dartmoor
http://members.aol.com/
adpasec/myhomepage
www.dartmoorpony.com

Donkeys, Mules, and Hinnies
www.lovelongears.com
www.spottedass.com

Dutch Warmblood
www.nawpn.org

Exmoor
http://exmoorenthusiasts.
fortunecity.com
www.exmoorponysociety.org.uk

Fell
www.fellpony.org
www.fpsna.org

Florida Cracker
www.floridacrackerhorses.com

Friesian
www.fpzvusa.com
www.fhana.com
www.friesianhorsesociety.com

Galiceno
817-389-3541

Gotland
www.gotlands.us

Gypsy Vanner
http://vanners.org

Hackney Horse
www.hackneysociety.com

Hackney Pony
www.hackneysociety.com

Haflinger
www.haflingerhorse.com

Hanoverian
www.hanoverian.org

Holsteiner
www.holsteiner.com

Hungarian
www.hungarianhorses.org

Icelandic
www.icelandics.org

Irish Draught
www.irishdraught.com
www.irishdraught.ie

Kentucky Mountain Saddle Horse
www.kmsha.com
www.mtn-pleasure-horse.org

Kerry Bog
www.kerrybogpony.org

Kiger Mustang
www.kigermustangs.org

Lac La Croix
www.nexicom.net/~hfm2/llcips.html

Lipizzan
www.uslr.org

Mangalarga Marchador
www.usmarchador.com

Marwari
www.horseindian.com

McCurdy Plantation
www.mccurdyhorses.com

Miniature
www.amha.org
www.shetlandminiature.com

Missouri Fox Trotter
www.mfthba.com

Morab
www.morab.com
www.puremorab.com

Morgan
www.morganhorse.com

Mustang
www.ambainc.net
www.blm.gov

National Show Horse
www.nshregistry.org

Newfoundland
www.newfoundlandpony.com

Nokota
www.nokotahorse.org

North American Spotted Draft
www.nasdha.net

Norwegian Fjord
http://nfhr.com
www.fjordhorseint.no

Oldenburg
www.isroldenburg.org
www.oldenburghorse.com

Palomino
www.palominohba.com

Paso Fino
http://puertoricanpasofino.org
www.pfha.org

Percheron
www.percheronhorse.org

Peruvian Paso
www.napha.net

Pinto
www.pinto.org
www.pintohorseregistry.com

Pony of the Americas
www.poac.org

Pryor Mountain Mustang
www.pryorhorses.com/pmmba.htm

Racking Horse
www.rackinghorse.com

Rocky Mountain Horse
www.rmhorse.com

Sable Island
www.greenhorsesociety.com

Selle Français
www.sellefrancais.org

Shackleford Banker Pony
www.shacklefordhorses.org

Shagya Arabian
www.shagya.net
www.shagya-isg.de

Shetland
www.shetlandminiature.com

Shire
www.shirehorse.org

Single-Footing Horse
www.singlefootinghorse.com

Sorraia
www.spanish-mustang.org/startsms.
 htm

Spanish Barb
www.spanishbarb.com

Spanish Colonial Horse/Spanish Mustang
www.horseoftheamericas.com
www.southwestspanishmustang
 association.com
www.spanishmustang.org

Spanish Jennet
www.spanishjennet.org

Standardbred
www.ustrotting.com

Suffolk Punch
www.suffolkpunch.com

Sulphur Horse
www.americanspanishsulphur.org

Tennessee Walker
www.twhbea.com

Thoroughbred
www.jockeyclub.com

Tiger Horse
www.tigerhorses.org

Trakehner
www.americantrakehner.com

Welara
www.welararegistry.com

Welsh and Cobs
www.welshpony.org

Wilbur-Cruce Mission Horse
www.spanishbarb.com

Parts of a Horse

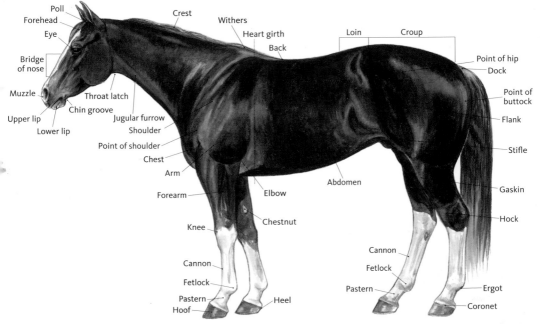

Poll
Forehead
Eye
Bridge of nose
Muzzle
Upper lip
Lower lip
Throat latch
Chin groove
Jugular furrow
Shoulder
Point of shoulder
Chest
Arm
Forearm
Knee
Cannon
Fetlock
Pastern
Hoof
Heel
Crest
Withers
Heart girth
Back
Elbow
Chestnut
Loin
Croup
Point of hip
Dock
Point of buttock
Flank
Stifle
Gaskin
Hock
Abdomen
Cannon
Fetlock
Pastern
Ergot
Coronet

RARE

PONY

LIGHT
HORSE

HEAVY
HORSE

COLOR

Abaco Barb

The ancestors of these colorful horses may have swum ashore from Spanish shipwrecks, or they may have arrived in the Bahamas with Loyalists fleeing the American Revolution. Only twelve horses of the breed currently exist.

HEIGHT: 13 hands

DESCRIPTION: Typical Spanish traits; head long between eye and muzzle, with large nostrils and heavy bone above the eye. Of the twelve living horses, most are pintos and the rest are bay or strawberry roan.

SPECIAL QUALITIES: Some individuals rack or pace

BEST SUITED FOR: Surviving without human intervention

PLACE OF ORIGIN

Great Abaco, Bahamas, sometime during the 16th century

ANCIENT RELATIVES OF THE HORSE *evolved in North America but disappeared more than 10 thousand years ago. Over the past 500 years the modern horse has returned, arriving first with the Spanish and then with other European settlers. We now have a rich diversity of breeds that often reveal the uses and preferences of their original homelands.*

Today's breeds have a variety of abilities, temperaments, colors, and body types. Some exhibit the classic Spanish Barb traits of straight or convex facial profile, low-set tail, and superior "cow sense"; others have more Arabian features, such as a dished profile and extraordinary endurance. Still others demonstrate the best qualities of a mixture of many bloodlines.

Here is an introduction to 96 breeds that may be encountered in North America today. This book is intended to be an easy reference guide. For more detailed information on breeds and their histories see Storey's Illustrated Guide to 96 Horse Breeds of North America *(Storey Publishing, 2005).*

*The mission of Storey Publishing is to serve our customers by
publishing practical information that encourages
personal independence in harmony with the environment.*

Edited by Deborah Burns
Art direction by Vicky Vaughn
Cover design by Kent Lew
Text design and production by Liseann Karandisecky
Cover photographs by © Bob Langrish: Paso Fino (front) and Lusitano
 (spine); © Chris Hurd: American Indian Horse (back)
Interior photographs by © Bob Langrish, except: © Linda Ashar 95;
 © Jay Goss Photography 129; © Shawn Hamilton/CLIX Photography
 99, 127; © Chris Hurd 11; © Carolyn Mason 159; © Adam Mastoon 131;
 © Deborah McMahon-King 173; © Jared Nield 179; © Only Horses
 Picture Agency 33, 87, 161; © Lynne Pomeranz 149; © Milanne Rehor 3;
 © Pam Salzer 185; © Becky Siler 119; © Paula Sue Swope 109;
 © Marye Ann Thompson 43; © Tom Vezo 195; © Perry Whipple 51
Illustration by © Elayne Sears 204
Maps created by Ilona Sherratt

The information in this book is true and complete to the best of our
knowledge. All recommendations are made without guarantee on the
part of the author or Storey Publishing. The author and publisher disclaim
any liability in connection with the use of this information. For additional
information please contact Storey Publishing, 210 MASS MoCA Way,
North Adams, MA 0124.

Storey books are available for special premium and promotional
uses and for customized editions. For further information, please call
1-800-793-9396.

Printed in China by Toppan Leefung Printing Limited
10 9 8 7 6

LIBRARY OF CONGRESS CATALOGING-IN-PUBLICATION DATA

Dutson, Judith.
 Horse breeds of North America / by Judith Dutson.
 p. cm.
 Includes index.
 ISBN 978-1-58017-650-7 (pbk. : alk. paper)
 1. Horse breeds — North America. 2. Horses — North America. I. Title.
SF290.N7D86 2006
636.1097 — dc22

 2006013882

HORSE BREEDS
of NORTH AMERICA

Text by Judith Dutson • Photography by Bob Langrish

Storey Publishing

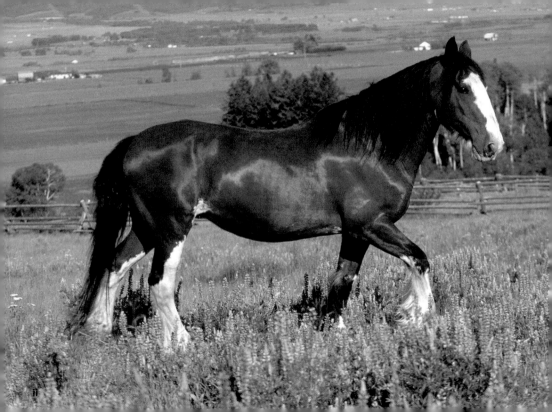

HORSE BREEDS
of NORTH AMERICA